D1362391

PAINTING DETAIL
IN
WATERCOLOUR

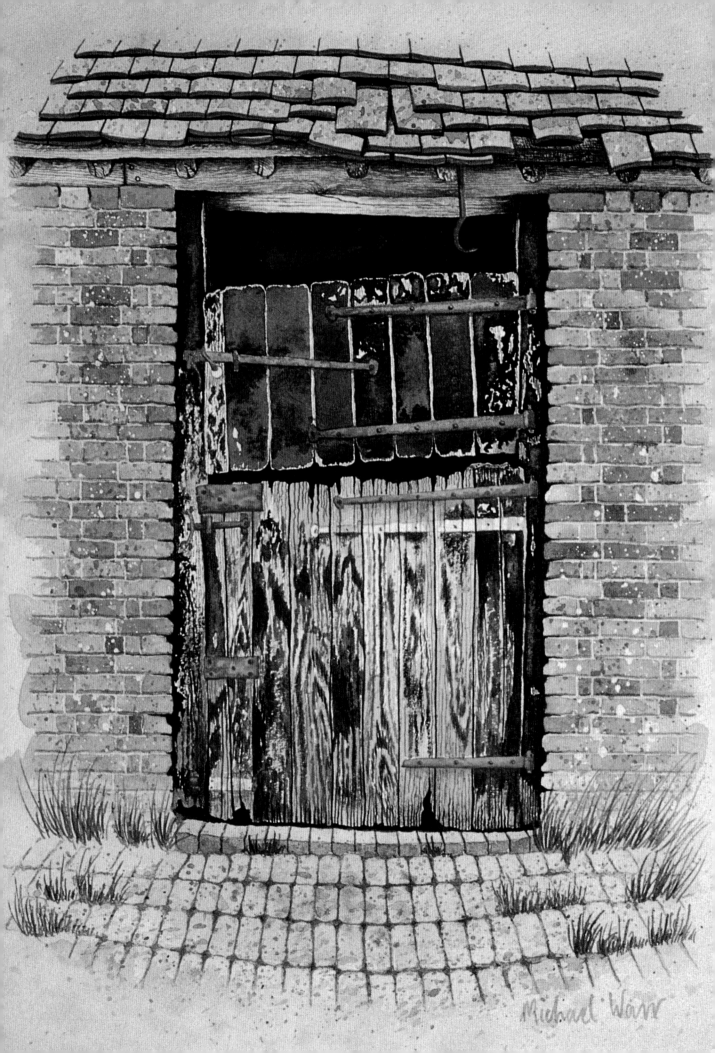

Michael Warr

PAINTING DETAIL
IN
WATERCOLOUR

Michael Warr

DAVID & CHARLES
Newton Abbot London

FRONTISPIECE
Last Hinges
Watercolour, 300x225mm
(see also page 46)

For Connie and Horace

British Library Cataloguing in Publication Data

Warr, Michael *1941 –*
 Painting detail in watercolour.
 1. Watercolour paintings. Detailing. Techniques
 I. Title
 751.422

ISBN 0–7153–9405–3

Typeset and designed by John Youé
on a Macintosh system
Printed in Singapore
by C.S. Graphics Pte. Ltd
for David & Charles Publishers plc
Brunel House Newton Abbot Devon

CONTENTS

ACKNOWLEDGEMENTS 6

WHY PAINT DETAIL AND TEXTURE? 7

DRAWING EQUIPMENT AND TECHNIQUES 8
Pencil 9; Coloured pencil 14; Water-soluble coloured pencil 14;
Felt tip16; Pen and ink 18

MATERIALS AND EQUIPMENT 20
Watercolour 20; Gouache 22; Acrylic 23; Egg tempera 24

TECHNIQUES 26
Watercolour 26; Drybrush watercolour 32;
Gouache 34; Acrylic 36; Egg tempera 40

STEP-BY-STEP GUIDES 45
Last Hinges 46; Mountain Hut 50; Clinker Built 56;
Bless This House 60; At the Ready 66; Drying Beauty 70;
Kerry 76; Alpine Daisies 80; Beetle Sculpture 84;
Gertch 88; Henry 92; Last of the Ayrshires 98

GALLERY 103

POSTSCRIPT 126

INDEX 127

ACKNOWLEDGEMENTS

I would like to thank the following for help in the production of this book:
Typing – Debbie Quirke and Margaret E. Alker; Photography – Geoff Holmes;
Materials – Daler-Rowney and Caran d'Ache; Help and assistance – Muriel Smith;
Editor – Faith Glasgow; Designer – John Youé

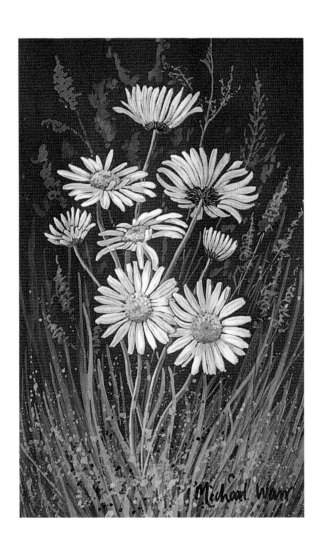

WHY PAINT DETAIL AND TEXTURE?

Detailed painting need not be as daunting as it sounds; it is very much an individual pursuit and there are a million ways in which it can be approached. In the following pages my personal approach to this fascinating and extremely varied activity will be described. It must be stressed that all the art teacher can do is guide and make suggestions because, above all, the teaching of painting is a sharing activity on a personal basis.

I have lived both in country and town so coming to terms with painting subject matter has been very interesting. The rural and urban atmosphere offer differing subjects and approaches. My interest in detail and texture has been forged by living in these very different surroundings. At present the countryside is my home and the cottage in which I live has exposed beams, some bare brick walls and a collection of bric-à-brac acquired from second-hand shops – the original junk! When combined, these elements help to stimulate my creativity and imagination – even cobwebs are retained and cultivated ready for observation!

Over the years the proximity of much loved subject matter has led me to observe and discover the beauty of worn and knotty wood, lichen on posts, rusty nails, the texture of corroding bricks and flaking lime mortar. I become very excited by the textures and feel the compulsion to share their beauty through a drawing or painting. My paintings are most successful when I have been able to absorb the subject matter slowly. Considerable time is spent studying and just looking before making a start on a drawing or painting.

Part of the excitement is when the image produced takes on a style or identity of its own. Painting is a fusing together of technique, which is knowledge of the materials gained by use and experiment, plus ideas, imagination and emotion which have to come from within. If true feeling for the subject matter is not there the best work cannot be produced. Too many students dwell solely on technique; ideas, imagination and emotion, all equally important, are often ignored!

Strangely enough, although my work is very representational now, it was painting abstracts which helped me develop a love of detail and texture for its own sake. Shape and colour became important as did the possibility of using uncompromising subject matter. Ben Nicholson, the abstract painter, influenced me during this period. His compositions, in my view, were simple but extremely sensitive. He had a tremendous sense of composition, a genuine feeling for the perimeter of his chosen painting area. I have tried to develop a similar sensitivity by carefully arranging the subjects in a painting to suit the proportion of the surface area.

In order to paint detail it is necessary to *observe* detail very carefully. Admittedly, after observing, painting detail needs practice but half the battle is developing the art of looking and then seeing potential subject matter. I find that after looking, observing, studying, thinking and feeling about the subjects, it is necessary to come to terms with them by drawing in an analytical way. This helps to solve visual problems at an early stage, enabling total involvement when pure painting is required. There is nothing worse than being dogged by problems of a basic nature when the paint should be flowing! The media I use are the water-based ones; acrylic, watercolour, egg tempera and gouache. These will be discussed and demonstrated in the pages that follow.

DRAWING EQUIPMENT AND TECHNIQUES

Preliminary drawing is a vital step towards producing detailed paintings. The drawing materials I use tend to encompass the whole range, but choice should depend very much on the individual situation. Out on location you might have the minimum of equipment but in the studio, of course, everything is to hand. However, it is important, even when out in the field, to have a reasonable range available.

My equipment is carried in a small travel bag which has a divided inner section and zip pockets. This provides some sense of order rather than everything being jumbled together in one area. A small light-weight folding stool is useful when drawing out-

A portable watercolour set including a small box containing pans of colour, collapsible plastic water container, telescopic brushes, sketch pad, folding stool, small light drawing board and a travel bag with pockets

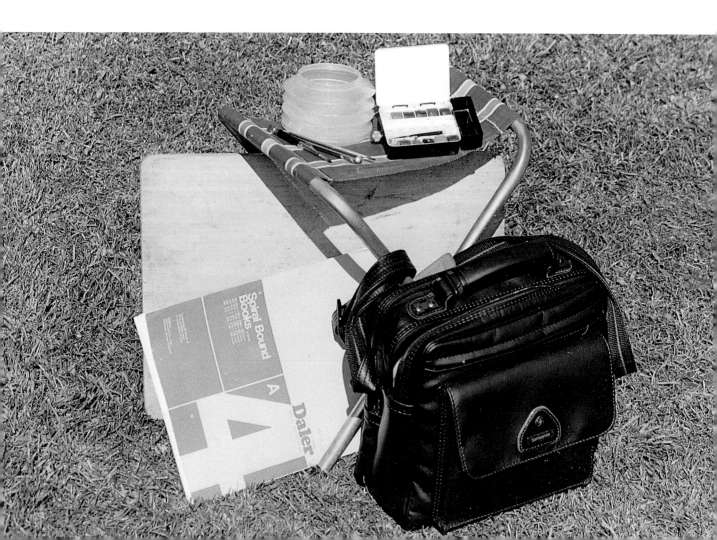

doors. It is important to be comfortable when drawing and painting as all your concentration can be directed into your work. A small lightweight drawing board is recommended if it can be carried without too much difficulty.

Back in the studio, I am fortunate enough to have a drawing table which swivels and this can be set at any angle to suit the drawing or painting in hand. This was rescued by a friend of mine some years ago as it was about to be burned! Another large drawing board is set up in a corner of the studio resting on blocks of wood, cut at 15⁰, which stand on a table top. This provides another practical and comfortable method of working. A stool and a chair help me to cope with differing working heights.

PENCIL

When drawing detailed subjects it is essential to have a good range of graphite pencils in order to record differing tones or shades as well as strong outlines. Some people may say 'a pencil, is a pencil, is a pencil',

Left
Study made with portable watercolour equipment

Below
Graphite pencils of different grades in a box, plastic rubber, steel blade in holder, file and cartridge paper

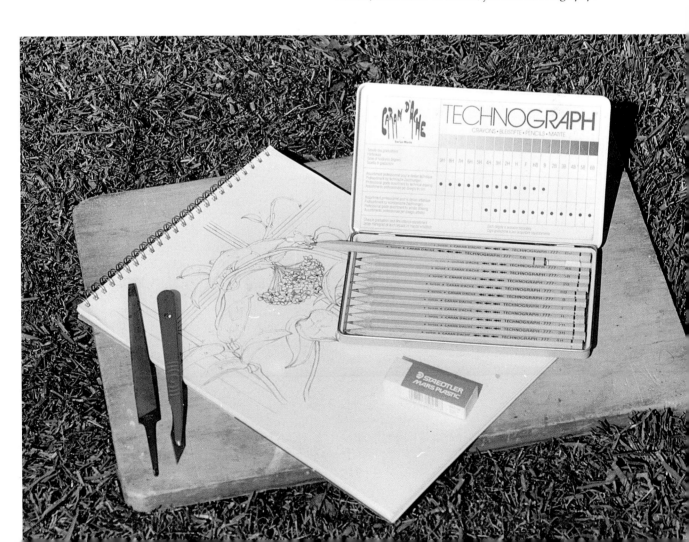

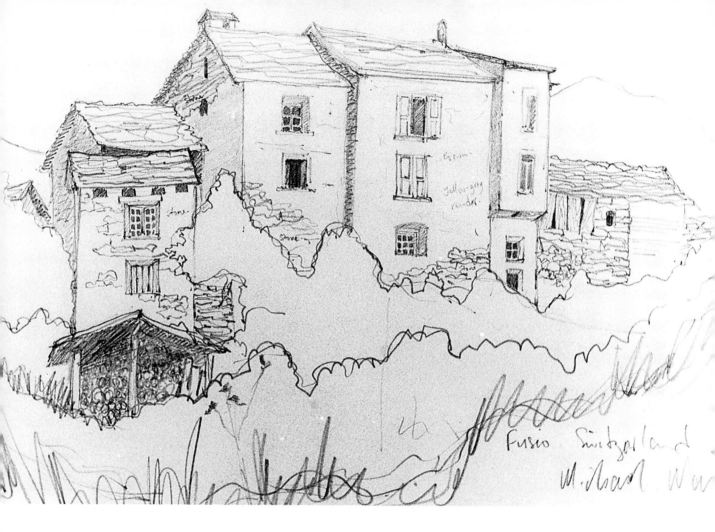

but there are many different grades available which can be very confusing for the beginner. To simplify matters, here is a table of 'hard' and 'soft' pencils.

6H	**hardest**
5H	
4H	
3H	
2H	
H	
HB	
B	
2B	
3B	
4B	
5B	
6B	**softest**

The H pencils above the line are 'hard' and normally used by designers in industry or architecture, whilst the B pencils below the line are 'soft', making them flow easily and as a result are suitable for the freehand drawing or sketching artist. Note that the higher numbers in the H range are the hardest pencils whereas the higher numbers in the B range are the softer pencils. With the softer grades, that is from HB to 6B, it is possible to obtain a wide variety of tones or shades, particularly important if a 'finished' drawing is required. A good finished drawing needs all the intermediate tones from white, light grey, mid-grey and dark grey through to almost black, just as a good black-and-white photograph usually depends on the same range of tonal values to be successful. Many students complain about their drawings saying, 'there is something wrong with this; it is grey.' Normally it is nothing to do with their inability to draw but wrong choice of materials. It is impossible to produce a drawing containing all the necessary tonal values with a very hard 6H pencil!

A 'quality of line' needs to be developed with pencil, ie some way of being expressive, possible even with the most basic of drawing instruments. A simple method is to alter the pressure applied to the pencil as a line is drawn; this gives interest to the line, introducing an everchanging tonal value. One way to make this exercise easier is to draw a light line first with an HB pencil and then draw over it with a 2B or 3B. The softer pencil applied in this way produces an excellent quality of line.

It is important to keep pencils very sharp, especially when drawing detail – fine line and detail cannot be produced with blunt leads. A sharp pencil can be used like a dart, recording an immediate reaction to the subject. Pencil sharpeners are useful but they have an irritating habit of breaking the lead just as a suitable

point is obtained; a craft knife tends to be far more efficient and easier to control. A small file is an excellent aid in maintaining a point whilst working (in between the times when the pencil actually needs sharpening). It is not a good idea to sharpen a pencil down to a stub so that you cannot see the point when you draw but if you do so, the life of the pencil can be extended by using a metal holder, thus enabling it to be used almost down to the end.

It is not cheating to use a rubber, it is the simplest way to eliminate unwanted lines. Plastic erasers are very easy and clean to use. They do not seem to damage the paper surface if used carefully and have the advantage of normally being housed in a sleeve which keeps the eraser very clean.

Surfaces on which graphite pencil may be used vary enormously. Cartridge paper or illustration board usually provide the most suitable backgrounds for finished drawings but interesting effects can be obtained by drawing onto textured surfaces such as watercolour paper, rough cartridge and pastel papers, both white or tinted.

Above
A partially completed example of developing 'quality of line' using an HB pencil followed by a 2B. Dark shading behind the subject is produced with a 6B, pushing it forward and giving extra impact

Left and below
Graphite pencil sketches made on location

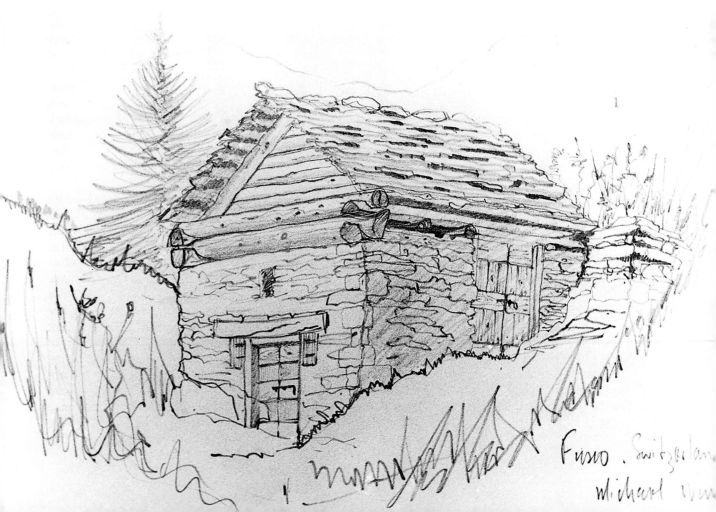

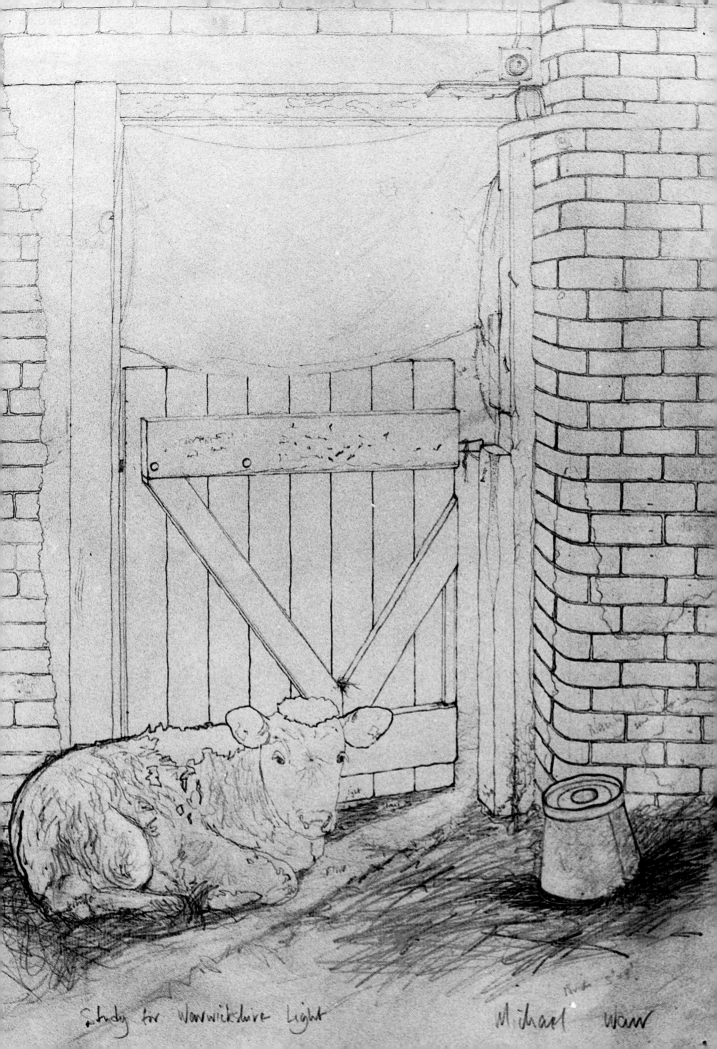

Study for Warwickshire Light Michael Waw

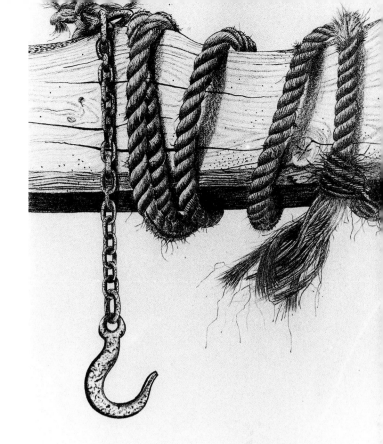

Left
Study drawing for Warwickshire Light *HB and 3B graphite pencils*

Right and below
JUTE, WOOD AND STEEL /PINE CONE
Finished drawings completed with a range of graphite pencils from HB to 6B. Note the span of tonal values, white through to almost black

A study using Caran d'Ache non-water-soluble coloured pencils. Some of the colours are produced by overlaying one on another

COLOURED PENCIL ▬▬▬

Caran d'Ache produce a wonderful range of coloured pencils. These offer the precision of the graphite pencil combined with colour. The leads are not too hard but not so soft as to crumble the first time they are used (important when trying to depict detail with precision). The coloured pencil is useful when making studies of intricate and colourful subjects. The colours can be overlaid to produce the desired effect.

Sometimes it is very difficult to remember a certain colour exactly, when back in the studio, yet it could be the key to a whole composition. Being able to record subjects quickly, when on location, is a distinct benefit. There is a tremendous advantage in being able to work immediately without the fuss and paraphernalia of painting equipment particularly if you are on the move, using public transport or in a restricted situation such as a waiting-room or hotel lobby. Of course, under controlled conditions, it is possible to produce highly finished drawings with a good range of coloured pencils. Again, as with graphite pencils, it is essential when depicting detail to keep a sharp point, and a knife rather than a pencil sharpener tends to be far more suitable.

The surfaces on which coloured pencils work best are exactly the same as those for graphite pencil work. It is worth remembering, though, that unlike a graphite pencil the coloured pencil cannot be erased very easily. Careful scraping with a sharp blade is probably the best method.

COLOURED PENCILS
Caran d'Ache water-soluble and non-soluble coloured pencils in various sets

WATER-SOLUBLE COLOURED PENCIL ▬▬▬

Caran d'Ache also produce coloured pencils which are water soluble. If a coloured drawing is required fairly quickly, but there is time to use a brush and water, these are ideal. There is a certain joy in working with dry watercolour paper onto which the water-soluble colour is applied. Then with a large soft, round pointed brush, wash on clear water and watch the exciting results. The image softens immediately, the

colours merge and a whole new feeling about the work transpires. Equally, if the paper is dampened and then lines drawn with a pencil, the initial effect is a soft line and some colour wash. When the paper dries it is then possible to work back into the study and accent certain areas as desired. A fairly heavy watercolour paper such as Bockingford 140 or 200lb is the best surface for these techniques.

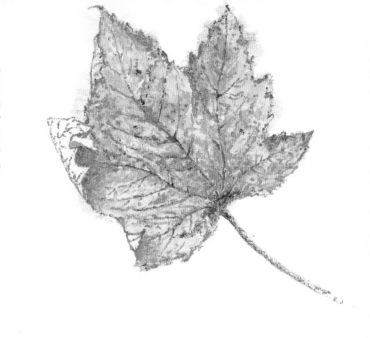

Right
This illustration shows the use of Caran d'Ache water-soluble pencils. Watercolour paper is sprayed with water and the image drawn quickly. The colour spreads giving a soft effect

Below
A two-minute sketch with water-soluble pencils

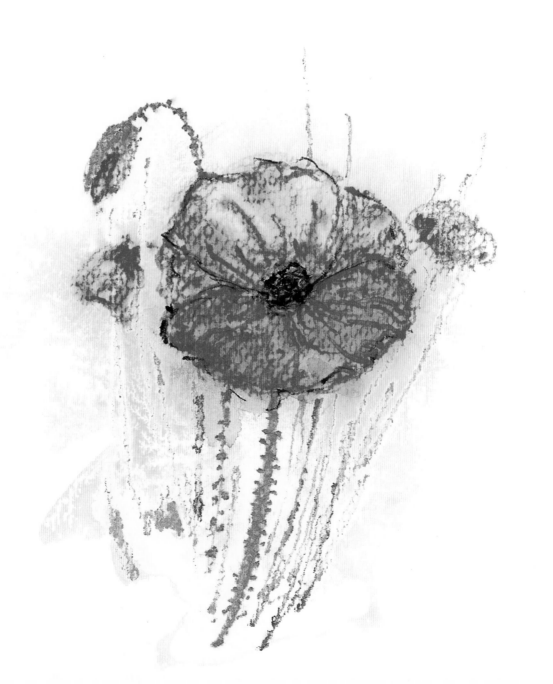

FELT-TIP

Felt-tip, or fibre-tip pens and markers can be bought in all shapes, colours and sizes. The choice is mind-blowing but I use a small range produced by Caran d'Ache to assist drawing detail. The fibre tips' instant use is very appealing; they do not need to be sharpened and glide over a surface very easily, whether it be smooth cartridge or textured watercolour paper. Black is a good choice for quick bold results. Because of their flowing capabilities fibre tips are able to record shapes and initial reactions with an almost unrivalled immediacy. A fine tip plus a broad tip can be used to block in a large area very quickly. Caran d'Ache produce fibre tips and markers with both water-resistant and water-soluble inks; the latter being most useful for artwork.

The tip of a water-soluble pen is impervious to water therefore it is necessary to wait until the ink has been applied to the surface before witnessing the astonishing results. It is better to work onto a heavy watercolour paper such as Bockingford 140 or 200lb. If water is washed over the drawn line with a soft brush, there is an immediate softening of the line and black changes to subtle greys, with a hint of pink and green. This effect introduces mood and atmosphere to the drawing, triggering off ideas which may be included in a painting later on. Incidentally, Caran d' Ache offer a three-year storage guarantee on their fibre-tip pens and markers.

A selection of permanent markers and water-soluble pens

A quick fibre-tip sketch with written notes

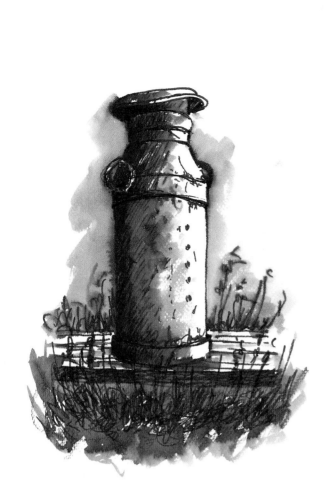

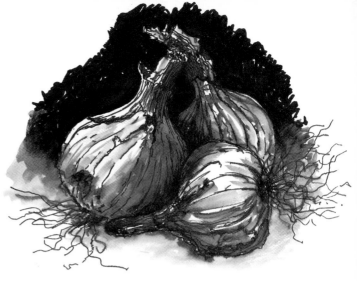

Left and above
Two drawings made with Caran d'Ache water-soluble fibre-tip pens. The drawings were completed on dry watercolour paper and finally water was applied with a brush. This helped to soften some of the lines and produce a gradation of tones. Note in the drawing of the onions how the dark background has been used to push the subjects forward

Below
An old house-boat on a canal depicted with water-soluble fibre-tip pen and then sharpened with a mapping pen and ink

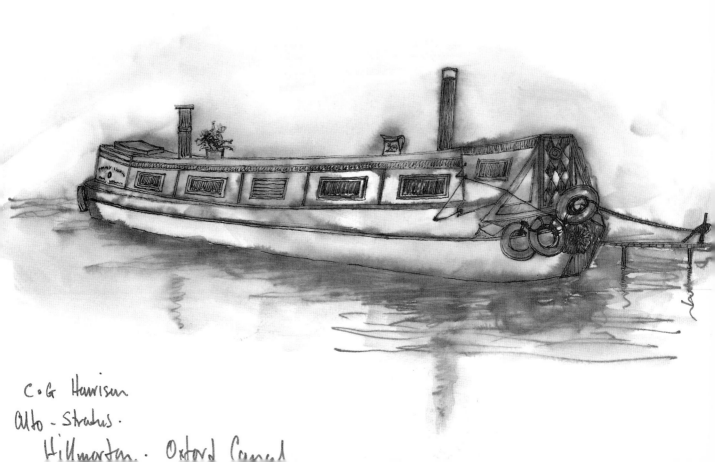

C.G Harrison
Alto - Stratus.
Hillmorton . Oxford Canal

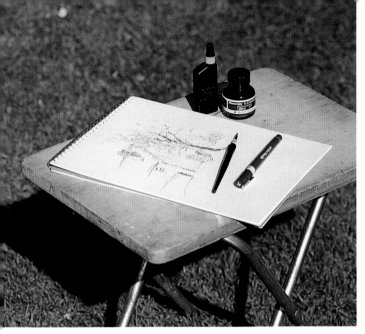

is to use a Rotring reservoir pen. The ink is discharged through an orifice via a small tube. There is a considerable size of line range available but the 0.35mm line thickness is a suitable one for the average, freehand artist. Rotring also supply a full range of inks for use in their pens and as it is necessary to keep the pen extremely clean they also produce a complete cleaning kit. The ink supplied for use with these pens is permanent – as it is not water soluble, it is difficult to erase. Light scratching is the best method to remove unwanted lines.

The best results, when working with ink, are obtained by working onto heavy cartridge paper and very smooth, or slightly textured, illustration board. The softer watercolour papers are not very suitable as the surface tears very easily and the 'fluff' produced will clog the nib.

It is possible to use combinations of all the aforementioned media in one drawing, or at least some of them, with great effect. Apart from capturing the detail required, combining techniques and mixed media can produce an interesting and pleasing end result in its own right. It is worth experimenting with a mixture of pencil and ink or coloured pencil and felt-tip pen, both permanent and water soluble. Presentable and finished pieces of work can be achieved fairly quickly, providing excellent information for more detailed and complex paintings which may be produced at a later stage.

Mapping pen, Indian ink, Rotring pen and ink, cartridge paper

PEN AND INK

One of the simplest ways to draw fine detail with ink is to use a mapping pen. This is a cheap dip pen and is particularly useful when introducing the beginner to ink. The nib of a mapping pen fits into the holder when not in use, offering protection against damage.

Another, rather sophisticated, way of applying ink

Study for Saying Goodbye *made with a Rotring pen and ink*

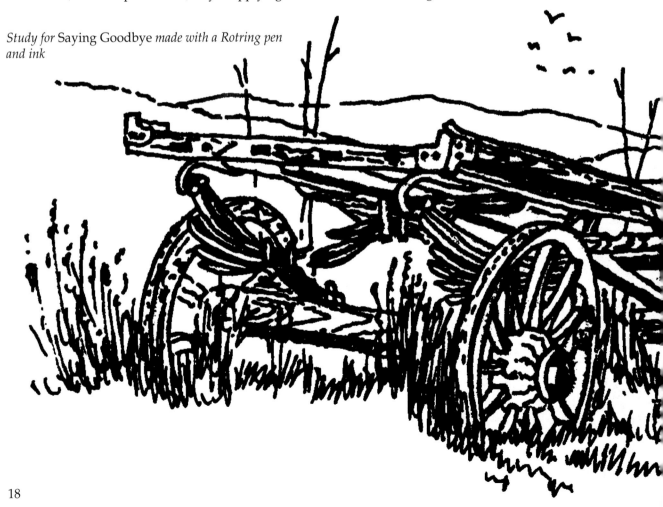

Above
*A cheap mapping pen and Indian ink were used to
produce this drawing. Ink was 'blotted' at the bottom to
create texture*

Top right
Mixed media study for Post *showing the use of graphite
pencil, coloured pencil and watercolour. The background
has rather more texture and flowing quality than the
finished painting*

Right
*A drawing washed over with watercolour to create a
quick visual effect. This study gives an idea of how the
finished painting will look*

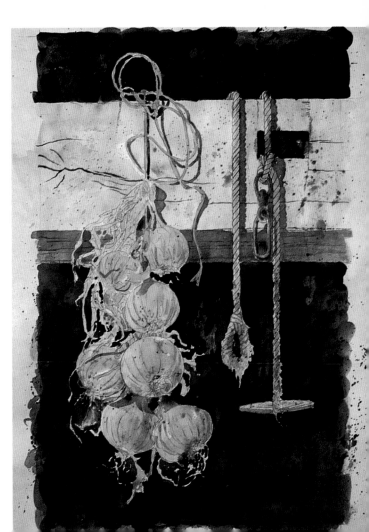

MATERIALS AND EQUIPMENT

The materials and equipment discussed on the following pages are the ones that I prefer to use for detailed paintings. The paints are all water based. This does not mean detail cannot be produced with oil paint but it is very slow drying and with so many stages in some of my paintings I find that the faster drying, water-based paints are more suitable. Waiting for oil paint to dry between stages can be very frustrating.

Water-based paints can be used in a dilute form but still retain their covering power enabling fine lines to be produced with only one application. A fine line painted with egg tempera can have tremendous punch and strength even when it is viewed from a considerable distance, as can a line produced with acrylic. Gouache and watercolour do not have quite the same strength but a line produced with either medium and a no 000 brush can be infinitely thinner than one produced with a pen. It is possible to work directly onto paper or card with water-based media, enabling detailed studies to be executed quickly without the fuss of preparing a surface first, as would be necessary with oil paint.

WATERCOLOUR

Paints

Watercolour is a beautiful medium, translucency being its main characteristic. Because of this translucent quality there is not the same scope for error as there would be with an opaque medium. This does not mean that minor mistakes cannot be corrected, or adjusted, with watercolour but generally speaking the medium requires a little more practice. For example, it is not possible to put light colour on top of dark colour; the painting must begin in a tentative manner and gradually progress towards the dark tones. The translucency of the paint is retained if it is applied to white watercolour paper. It is the whiteness of the paper shining through the paint that gives watercolour painting a special quality. If white pigment is added to the pure colour it becomes opaque, creating gouache; another medium entirely.

There is very often discussion between artists about the quality of the watercolour paint they use. I prefer the Rowney Artists quality; the colours tend to mix better and the effect obtained by granulation (a technique discussed on p26) is usually more intense with artists' quality paint. Good watercolour paints consist of a finely ground pigment with gum arabic as a binder. The water-soluble gum acts as a light varnish giving the colours extra brightness and sheen.

The manner in which watercolour is applied to the surface varies considerably between artists. Sometimes I use the paint in a free-flowing way, creating large washes and at other times I use what is known as the drybrush technique (the latter is discussed in the technique section in Chapter 4, p32). It is certainly a very useful method for conveying detail.

There is a tremendous difference between what artists regard as their palette or colour range. The watercolour paintings demonstrated in this book contain the following colours:

raw sienna	French ultramarine
burnt sienna	monestial blue
cadmium yellow pale	neutral tint
crimson alizarin	Paynes grey
rose d'ore	lamp black
warm sepia	titanium white gouache

WATERCOLOUR EQUIPMENT
Round pointed brushes nos 000 to 18, two flat wash brushes, a selection of tube colours, ceramic palettes, white gouache, masking fluid, palette knife, sponges, steel blade in holder and kitchen towels

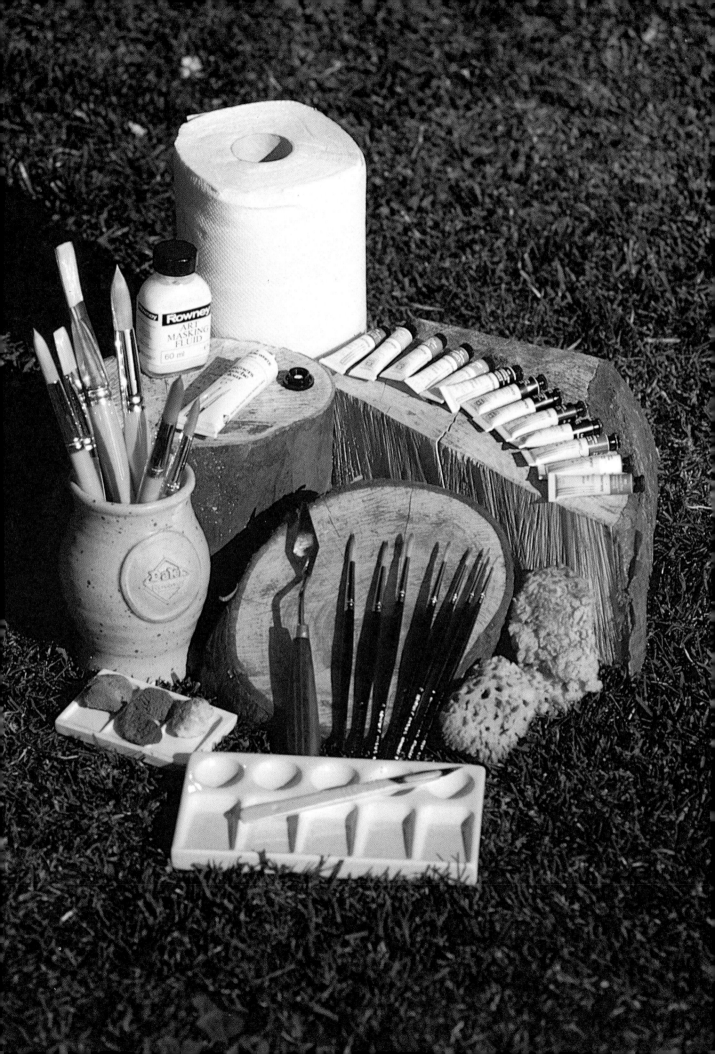

Paper

There are many watercolour papers to choose from. The various different weights and surface textures can be most confusing at times. Basically there are three main types of real watercolour paper: hot pressed or HP; 'not' (not hot pressed); and rough. Hot pressed is very smooth; 'not' is very popular because its semi-smooth surface will take large even washes but a dry brush dragged across its surface will produce a texture on what roughness exists. Rough paper has a 'tooth' to it and is ideal for conveying texture of all kinds. It is important for the beginner not to be intimidated by the roughness but to attack it with gusto!

The weight or thickness of a paper is easily explained. It is measured by size and ream. For instance, a ream of imperial size 250lb Bockingford would weigh 250lbs. Papers I have used in the demonstration paintings are: Bockingford 250lb, Waterford rough 200lb and Whatman rough 200lb. The Bockingford and Waterford are used for the paintings containing free-flowing passages whilst Whatman is used for the drybrush work because its rough surface is suitable for conveying detailed textures.

Brushes

Good watercolour brushes are made from kolinsky sable but these tend to be very expensive. There are brushes available made from synthetic fibres which are a good substitute for sable. The paintings in this book have been produced with a mixture of brushes: some with natural hair and some with synthetic fibre. The smaller brushes used (nos 000 to 6) are Rowney kolinsky sables, whilst the larger ones (nos 7 to 12) are Rowney Dalon (synthetic). There is not a great deal of price difference at the small end of the range between natural and synthetic brushes, but as the size increases, so does the price!

It is important when painting fine detail that the brush retains its point and I have found with the smaller sizes that the sables are better in this respect. As will be seen in the step-by-step guides, there is great emphasis on the use of small brushes (nos 000 to 2) for the very detailed areas, whilst for the larger, free-flowing passages, synthetic Dalon brushes are used. Dalon brushes are produced in the smaller sizes but they need to be replaced more often when used on roughly textured watercolour paper particularly if the drybrush method is being employed.

Palettes

Watercolour palettes are available in all shapes and sizes. The recessed or well types are the most suitable and are made from plastic or ceramic material. I prefer the ceramic ones as the paint does not 'skid' about on these but when a large amount of dilute colour is required, a coffee jar lid or plastic vending cup is very useful.

Easels

For detailed watercolours a stable easel or surface is essential. In the studio, a drawing board placed at a slight angle on a table top is suitable and for outdoor use I would recommend an aluminium sketching easel. These are easier to erect than the wooden ones and, being light in weight, easy to carry.

Other equipment

A variety of small pieces of natural sponge is useful for applying watercolour or removing it, as are tissues or pieces of kitchen towelling. Rowney art masking fluid, a water-resistant liquid, is a useful aid to the detail watercolourist, especially when the white of the paper is to be retained. Painting knives, usually associated with oil or acrylic painting, are also useful for certain types of watercolour painting. How to use the equipment described is explained in Chapter 4.

GOUACHE

Paints

Gouache is simply opaque watercolour and, as a medium in its own right, was discovered by an anonymous monk in the fourteenth century. He realised that by adding Chinese white to his transparent watercolours they became opaque. White gouache can be added to watercolours making them *very* opaque; a technique I often use in the foregrounds of watercolour paintings (see demonstrations on pages 27, 31, 52, 55).

In contrast to watercolour, it is possible to work from dark to light with gouache, adding white to lighten the colours, rather than diluting with more water. The addition of black will darken the colours and gives interesting results when mixed with red or yellow. It is worth experimenting with black, a colour which is taboo with many artists.

When using gouache as a sole medium, I prefer Caran d'Ache paint in tubes. Their range of thirteen permanent non-fading colours is adequate and comprises the following:

white	purple
black	violet
golden yellow	ultramarine
vermilion	cobalt
burnt sienna	emerald green
carmine	lemon yellow
yellow ochre	

Paper

The same paper can be used as for watercolour but with the addition of tinted papers because the medium is so opaque. Watercolours glow, the white paper underneath shining through the pigment, but the brightness of gouache comes solely from the reflecting power of the pigment in the paint surface.

Left
GOUACHE
Box of Caran d'Ache paint in tubes, ceramic palette,
selection of round pointed brushes nos 1 to 7

Brushes

In the main, watercolour brushes are suitable for gouache, especially when painting detail, but hoghair brushes, normally used for oil painting, can be used if the paint is applied thickly.

Palettes

Again, as with watercolours, the same palettes are suitable but, because dilution is not so necessary in every painting, a saucer can be useful.

Easels

Watercolour easels and surfaces are suitable for gouache.

Other equipment

Because gouache is prone to lifting when washes are applied one on top of the other, the introduction of an acrylising medium is useful. This is mixed with the paint on the palette and fixes the underlying wash if desired. Sometimes the lifting effect is useful; the resulting mixing of colour being very interesting, but if the required final effect is a clean one, the addition of the medium makes this possible.

ACRYLIC EQUIPMENT
Above
Tubes of paint, short-handled pointed brushes nos 000 to 12, long-handled flat brushes sizes 1 to 10, acrylic primer, palette knives, surface tension breaker and varnish

Below
Stretched canvas, canvas board, Rowney 'stay-wet' palette, paper palette, brushes and tubes of paint

ACRYLIC

Paints

To make acrylic paint, polymer resin is added to the pigment rendering it very tough and durable. It was first developed by Mexican artists during the thirties and was later taken up by artists in the United States, being introduced into Britain around 1960.

I have been using the medium since 1963 and find it very versatile. It can be used very thickly with a painting knife or diluted with water to a consistency resembling watercolour. Quick-drying properties make it suitable for detail work as layers can be applied in quick succession. I like to paint onto canvas and find acrylic painting a very suitable way of doing

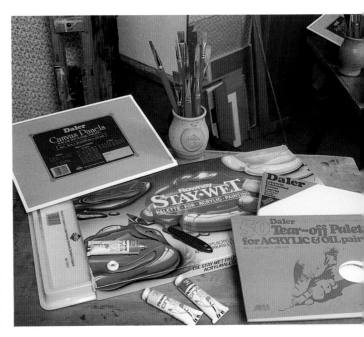

so, particularly when fine detail is required. It is almost indestructible, being resistant to the elements, making it a good medium for mural work either inside or out.

Acrylic is mainly supplied in tubes. The paint used in the demonstration paintings is Rowney Artists Cryla in the following colours:

Venetian red	burnt umber
cadmium yellow	Paynes grey
yellow ochre	cadmium scarlet
burnt sienna	crimson
raw sienna	ultramarine
titanium white	opaque oxide of chromium

Painting surfaces

Acrylic paint can be applied to virtually any unprimed surface: wood; glass; metal; paper; cardboard and canvas. Rowney stretched canvases and prepared canvas painting boards are particularly suitable for detail work. Pleasing effects can be obtained by painting onto a gesso-coated surface such as marine plywood or high-density fibre board. This type of surface is described fully on p25). The demonstration acrylic paintings are on canvas board and gesso-coated high-density fibre board.

Brushes

For detailed painting with acrylics, I find that Dalon watercolour brushes are suitable with the addition of two or three long-handled flat Dalon brushes. Great care must be taken when brushes are cleaned because of the toughness and quick-drying properties of the paint. If acrylic dries on a brush it is virtually instant death. Soaking overnight in methylated spirit to revive the brush is recommended by some experts; I have tried this, but without much success! When working on a painting, a good idea is to rinse the brushes thoroughly and lay them flat on a working surface. On no account should they be left standing in a jar of water, they will emerge looking like hockey sticks! Washing the brushes occasionally in warm, soapy water will help to keep them in good condition.

Palettes

Almost any non-absorbent surface is suitable as a palette for acrylic paint but, because of its quick-drying quality, Rowney have developed a 'stay-wet' palette, which comprises a shallow plastic tray with a clear plastic lid. Inside there is a sheet of waterproof paper to keep paint on and also absorbent paper which can be dampened. Under these conditions acrylic paint will stay moist for up to one week.

If the paint is going to be used quickly, say within a day, I use a tear-off paper palette in conjunction with a small plant spray. The idea being that if the paint is showing signs of forming a drying skin, it can be sprayed with fine, clear water. At the end of the day the paper can be thrown away.

Other equipment

It is essential to use a palette knife for mixing acrylic paint. Its consistency is that of a thick paste and therefore requires thorough mixing. A palette knife will do this properly. Using a brush for the purpose is not recommended; the paint and the brush become a clogged mess.

If an overall flat effect is required as in mural work, a flow improver can be added to the standard Cryla paint, making it flow evenly. A free-flow formula paint is also available for this purpose. A gel retarder is available for slowing the drying process. It can be mixed with the paint on the palette and is useful when blending is required in large areas of a painting, such as the sky in a landscape or the background in a portrait.

Varnishing is not necessary as the paint is very tough, but matt and gloss varnishes are available and can be applied to suit personal taste.

EGG TEMPERA

Paints

Tempera painting is one of the oldest forms of painting known to Man. It was certainly used by the ancient Egyptians to decorate the tombs of their kings; the results of which can still be seen today. This evidence proves the permanency of the medium.

The paint is made by simply mixing colour pigment with the yoke of an egg and distilled water – a pleasing and natural way to produce colour. There are other mixtures which can be used but an egg yoke and distilled water is the classic formula. Egg yokes contain albumen, a protein that sets hard, a non-drying oil and lecithin, a substance that helps liquids to combine in a stable mixture, therefore an ideal emulsion is obtained by mixing with pigment and distilled water.

A small glass container is useful for storing the mixture of egg yoke and distilled water. This can be kept in a refrigerator for up to one week. Egg tempera is a quick-drying medium and is better mixed in small quantities. It is possible to store mixtures of the emulsion and pigment in small air-tight jars for a limited time but I usually mix fresh colour each time that I paint.

Ready-made egg tempera in tubes manufactured by Rowney is available but because a preservative is added it tends to be greasy and takes longer to dry. Nevertheless, it is an ideal way for the beginner to become familiar with the medium before going on to the home-made method of making the paint.

EGG-TEMPERA EQUIPMENT
Tubes of Rowney tempera paint, colour pigment, gesso powder, rabbit-skin size, gesso panels, egg separator, palette, palette knife, eye dropper, a selection of round pointed and flat brushes

The following pigments were used in the demonstration paintings:

alizarin madder	French ultramarine
cadmium light red	yellow ochre
Hansa yellow deep	oxide of chromium
red ochre	lamp black
raw umber	titanium white
burnt umber	

Painting surface

The ideal surface for tempera painting should be firm and coated with gesso. The gesso powder can be bought and prepared by adding rabbit-skin size and water; ready-to-use liquid gesso is also available.

Marine plywood or high-density fibre board are excellent supports for gesso grounds. Cotton fabric stretched over the board with rabbit-skin size produces a very fine surface. It is necessary to apply four to eight coats of gesso, leaving it to dry between each coat. It should then be left to dry thoroughly for several days before final sanding and polishing with a moist cloth. To prevent warping the gesso should also be applied to the reverse side of the support.

Ready-prepared gesso boards are available in good art supply stores; buying one of these can save time if you are eager to start painting! The demonstration paintings were produced on cotton-covered high-density fibre board.

Brushes

Fine pointed sable and Dalon brushes as used for watercolour painting are suitable, with the addition of one or two wide flat brushes for initial dilute washes.

Palettes

Because the pigment and egg-yolk emulsion have to be mixed vigorously with a palette knife, paper palettes are unsuitable. A piece of plate glass with ground edges is ideal. White cartridge paper placed underneath is an advantage as this enables the colour to be seen clearly. It is important to keep the palette extremely clean, ensuring that no traces of old paint mix with the new!

Other equipment

A trowel-shaped palette knife is ideal for mixing the egg emulsion with the pigment and an eye dropper is a useful aid for adding the egg-yolk emulsion to the pigment prior to mixing. The flow improver used for acrylic painting can be added to egg tempera, particularly with the pigments that do not mix quite so easily with the emulsion, for example, Hansa yellow deep.

Some of the techniques discussed and illustrated in the following pages require the use of a model-maker's steel blade, therefore one of these is a useful addition to egg-tempera equipment.

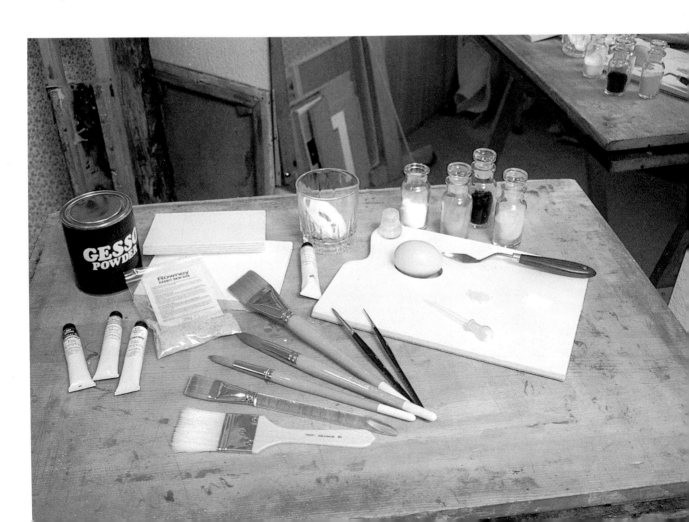

TECHNIQUES

Certain helpful techniques can be used when painting in detail. Before introducing the step-by-step guides, some of these techniques are discussed and illustrated to enable a greater understanding of certain stages. This approach eliminates the need to interrupt the flow of descriptions within some of the demonstration paintings. If you can practise some of these techniques from time to time the experience is invaluable when producing paintings with detail. It is worth re-membering that experimentation with techniques can lead to the discovery of ways in which to depict certain features of a subject. Textures, in particular, can be produced with many items other than traditional brushes. Gimmicks are not advocated but experimentation and creativity should be developed.

It is not necessary to fill every part of a painting with tight detail or the main subject can be lost. If detailed subjects are allowed to breathe by being surrounded by less detail or simple texture, the poignancy that they exude can have impact.

The following techniques are a combination of careful ideas and rather more free-flowing ones, providing the anatomy of detailed paintings. Try practising some of these techniques and remember it does not have to be one large stride – three small steps will do!

French ultramarine and crimson alizarin

Paynes grey and raw sienna

Cadmium yellow pale and lamp black

French ultramarine and burnt sienna

French ultramarine and light red

WATERCOLOUR
Left
GRANULATION
Effects produced by using colours which granulate. Granulation occurs when certain colours with differing pigment weights are mixed together, ie French ultramarine and crimson alizarin. French ultramarine is a much heavier pigment than crimson alizarin and consequently when the mixed colour is applied to the paper the pigments separate, the heavier one sinking into the 'dents' of the textured surface, whilst the lighter one sits on the 'bumps'

Right
FLICKING AND SPATTERING
Watercolour can be effective when it is flicked or spattered onto the paper. I use this technique frequently and find it useful for creating textures and depicting a mass of wild flowers in the foreground of a landscape. The effect is produced by holding the brush as normal but the index finger is used to tap the top of the brush – rather like flicking cigarette ash

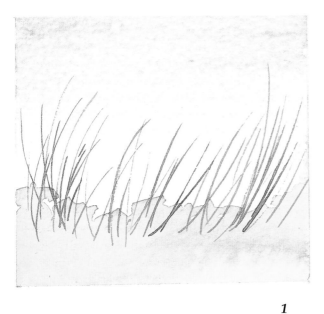

Three stages follow showing the use of flicking and spattering to produce wild flowers:

1 After light initial washes, the stems of the flowers are painted with a no 000 brush

2 Leaves are indicated on the stems and initial light flicking for the flowers. Colour is also flicked around the base of the stems. This allows them to 'disappear' into the undergrowth. White gouache is added to the watercolour, giving it strength and opacity

3 More spattering and flicking to build up the 'mass' of blooms. Colours added to white gouache are French ultramarine, crimson alizarin and cadmium yellow pale. Mixtures of these colours are added to the base but are blotted with tissue, diffusing them, but enabling them to echo the colours above. It is a good idea to mask the rest of the picture when spattering

1

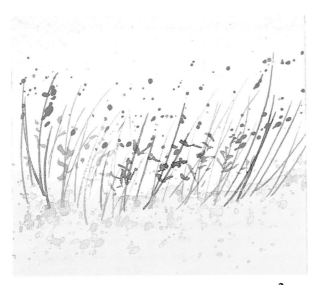

2

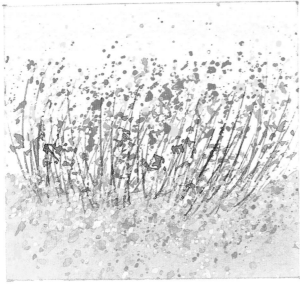

3

Below
An 'out of focus' effect created by flicking and spattering colour into a damp wash

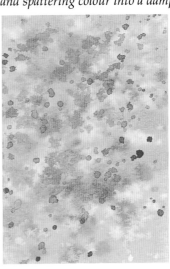

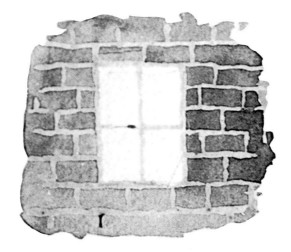

1

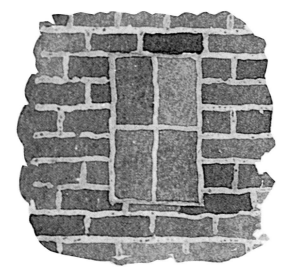

2

3

Of all the resists devised for watercolour painting over the years, art masking fluid is probably the most effective for retaining the white areas of paper. It does not work as well with gouache and not at all with acrylic or tempera; they are far too strong and simply bind it to the surface. Whatman paper, which I use for drybrush painting, does not accept it too easily but on Bockingford it works perfectly. Applying it thickly is not recommended – a thin covering is just as effective. Leaving it on the paper surface for a number of weeks is fatal – it should be removed after a few days at the most!

Left
Masking fluid used to retain the white of a windowframe and mortar between bricks shown in three stages:

1 Masking fluid is applied and when dry a wash is painted over the bricks

2 Because the fluid forms the windowframe, a wash can be applied to the glass panes without having to worry about the wet colour on the bricks

3 Whilst the brick and window washes are still damp, dark colour is 'fed' in to produce a convincing effect. When paint is thoroughly dry the masking fluid is removed by light rubbing with a finger

Below
Candle wax resist creates interesting texture when painted over with watercolour. Simply apply wax, paint over and when the paint is dry the wax can be removed by placing blotting paper on top and pressing with a warm iron

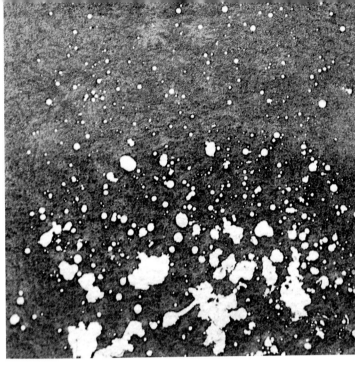

Below
Salt sprinkled into a damp wash created this effect

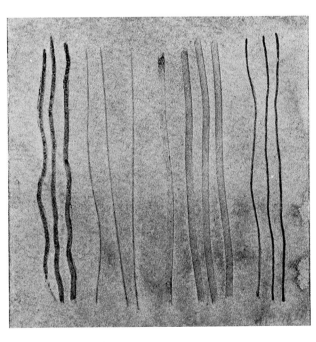

Above
Lines created by scoring the paper prior to applying a wash. Various instruments were used including the handle of a paint brush, palette knife, scissors and a 6H pencil

Right
These lines, painted with a no 000 brush, are probably as fine as lines produced with a pen and flow rather more easily

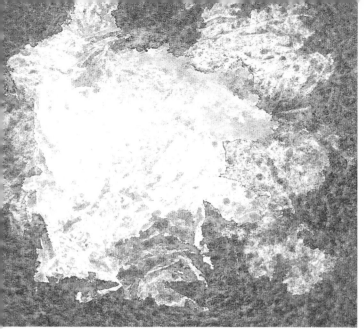

Above left
Kitchen roll tissue was used to remove wet paint thereby creating this texture

Above right
Natural sponge and watercolour made this texture

Right
A piece of damp natural sponge lifted the wet paint in this example

Left
Raindrops on this leaf were made by removing dry paint with a wet pointed no 2 brush. When the spots were dry, stronger colour was used to define them

Right
Three interesting landscape foreground textures:

*White gouache introduced into a damp watercolour wash
whilst, above, salt is sprinkled onto the wash*

Above
*The grasses are knifed out with a palette knife –
the immediate foreground texture is a result of dabbing
with tissue*

Below
*Sponging is used for the undergrowth out of which the
poppies are growing. These were painted whilst the sky
wash was still damp*

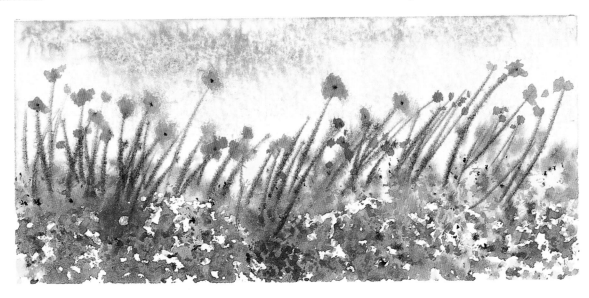

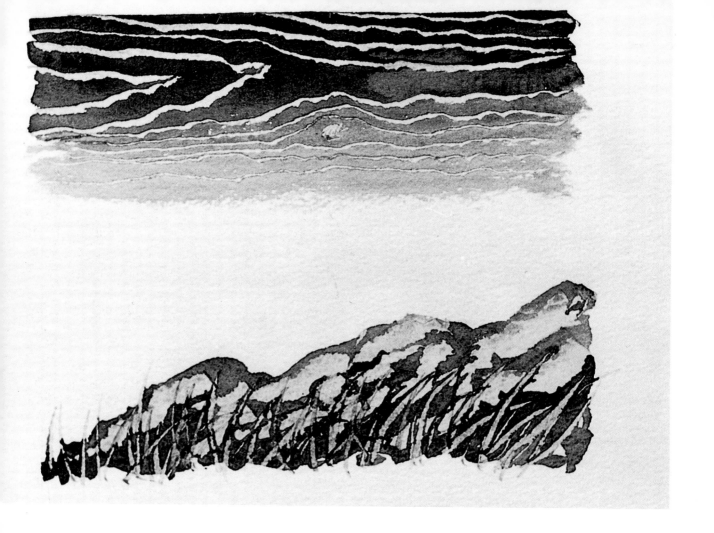

Above
These two effects were obtained by taking off wet paint with a palette knife. It is advisable to wait a few moments before removing paint; a very wet wash will fill in the spaces immediately but if the paint dries too much it is impossible to remove it – watercolour is very frustrating at times!

Left
Combination texture made by introducing black Indian ink into a wet watercolour wash followed by white gouache

DRYBRUSH WATERCOLOUR

The term 'drybrush painting' is a contradiction in terms, as it is impossible to paint with a completely dry brush. What it does mean is painting with a brush starved of colour – just enough remaining to mark the paper.

The drybrush method of painting is the one that I use to depict fine detail and texture with watercolour. Many people think that the paint is applied directly from the tube in its neat form but the process is exactly the opposite. Dilute the paint with a large quantity of water, dip the brush in and squeeze the excess moisture away, 'splaying' the bristles afterwards. This leaves just enough colour to pick up on the texture of

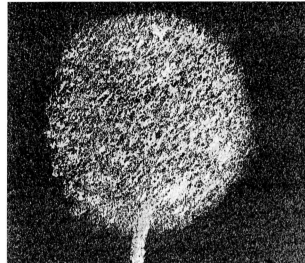

Drybrushing with one colour over a flat watercolour wash

Drybrush gouache over an acrylised gouache background. The ground is fixed and as a result there is no 'picking up' of colour when the overpainting takes place

Right
THREE SIMPLE STEPS IN DRYBRUSH PAINTING

1 Basic drawing of brick shapes over a luxurious watercolour wash with one layer of drybrush work

2 Another layer of colour is drybrushed over the bricks with a no 3 pointed brush

3 A third layer of colour is drybrushed over the bricks. Detail is added to the mortar and the bricks with a no 000 brush

It is important that each layer of paint is thoroughly dry before starting on the next, otherwise 'damp' colour is likely to 'pick up' and result in mud rather than clean, crisp texture

1

2

3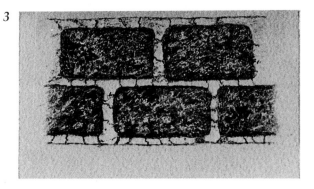

the paper without flooding it. This process needs to be practised: too much moisture ruins the effect.

Drybrush painting requires coming to terms with the texture of rough watercolour paper, that is, exploiting its textural possibilities. I have found Whatman 200lb rough to be the most suitable; the 'tooth' is just right for me to be able to convey all kinds of texture. Many of the papers that I have tried have a 'mechanical' texture whereas the texture of Whatman paper is very random, producing a much more natural effect.

It is important to lay down a luxurious wash first before drybrushing; the technique used directly onto white paper is not very effective as there is no depth and the painting does not come to life underneath.

Left
Opacity of gouache is demonstrated here. Light colour is applied over dark colour with a sponge

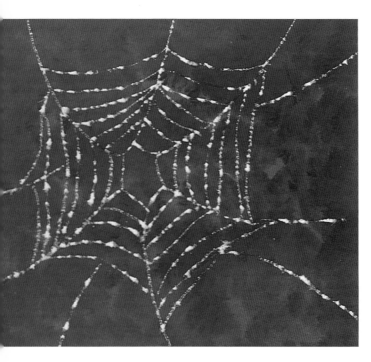

Left
A fine steel blade scratched into gouache. The rough surface of the paper tore and helped to create dew drops on this web

Below left
Strong lines produced with a no 000 brush and gouache

Below
Two wet washes of gouache which were allowed to merge

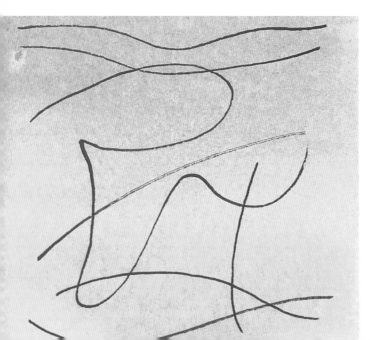

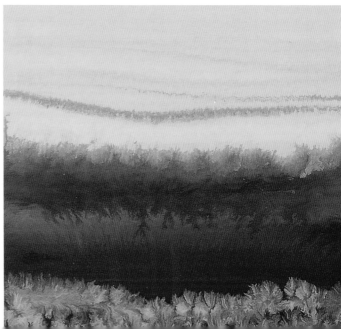

1

2

MIXED MEDIA TEXTURE

1 *Thick gouache is applied over a dry watercolour wash*

2 *When the gouache is dry, black Indian ink is painted on with a no 3 pointed brush*

3 *After the ink dries the whole thing is washed under the tap.*

The gouache dissolves quickly taking some of the ink with it. Traces of ink, gouache and watercolour create an interesting texture.

3

Left
An initial dilute wash of Venetian red laid with a flat 1in brush

Below left
Some drawing is often necessary before painting. Despite the opacity of acrylic, a wash if it is well diluted can be laid over the drawing without 'losing' it. The paint can then be built up in layers within the drawn shapes

Right
In this example the paint moves from being transparent to very opaque in just three stages

1 The paint is applied in the form of a very dilute wash

2 The paint is thickened a little more

3 Shows the opacity of acrylic when it is used with a creamy consistency. A 1in flat brush was used in each case

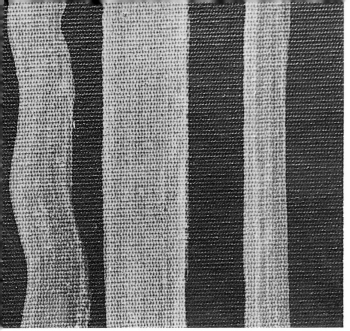

Above
The effect of painting semi-transparent paint over opaque. This technique is useful for producing glazes. The strength of the overpainting can be varied, depending on the effect required. Experimenting with glazes can be very interesting and I find that making notes about the various mixes is a useful exercise

Above right
Texture created by spattering, flicking and dribbling dilute paint onto the surface. White was added here and there, rendering some areas quite opaque

Above
Texture created by sponging dark colour over a light ground followed by spattering and flicking

Left
Light coloured texture over dark ground created with a natural sponge

37

Left
A rag dabbed onto wet paint created this effect. Various absorbent materials can be used including kitchen towelling, blotting paper and tissues

Below
Opacity of acrylic is demonstrated here. Only two layers were applied in the background and two layers of white were used to form the petals of the daisy

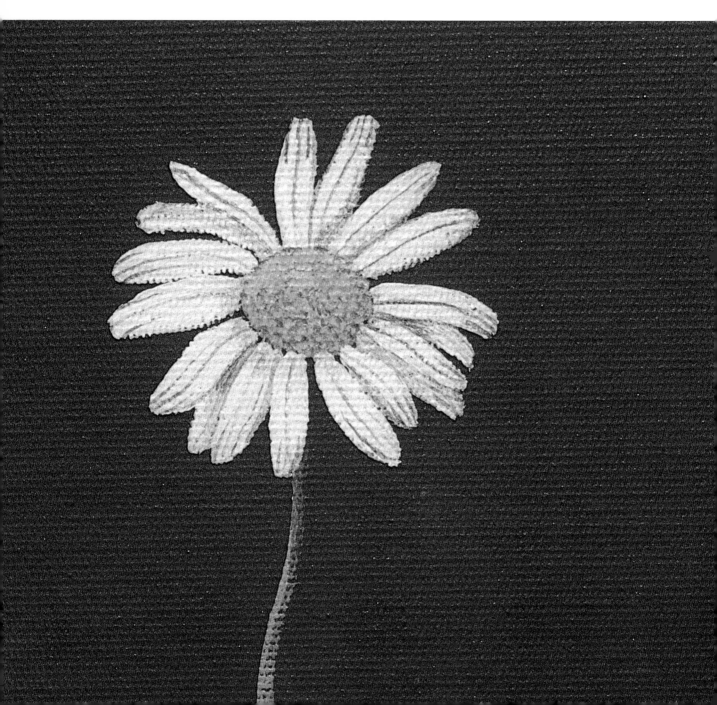

Two methods were used to produce these lines. The curved ones and the straight ones above were produced by scratching into the paint with a fine steel blade, whilst below, a no 000 brush was used

Drybrushing light colour over dark. The method used is the same as described for watercolour and gouache

Dark colour drybrushed onto a light wash

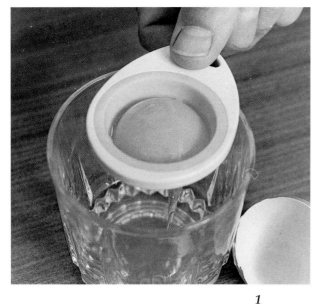

1

2

3

EGG TEMPERA

MAKING EGG TEMPERA PAINT

1 *The yoke of an egg is separated from the white*

2 *Rolling the yoke on kitchen towelling removes any excess grease*

3 *The yoke is contained in a sack; this needs to be punctured allowing 'pure' yoke to flow into a small glass container*

4 *Two teaspoons of distilled water are added to the pure yoke*

5 *Stirring is necessary to fuse the water and yoke together forming an emulsion*

6 *An eye dropper is used to add the emulsion to dry powder pigment*

7 *The pigment and emulsion are mixed together with a palette knife*

Right
Light initial wash applied with a wide flat brush

Far right
Raw umber sponged onto a background of at least two layers of dilute yellow ochre mixed with titanium white

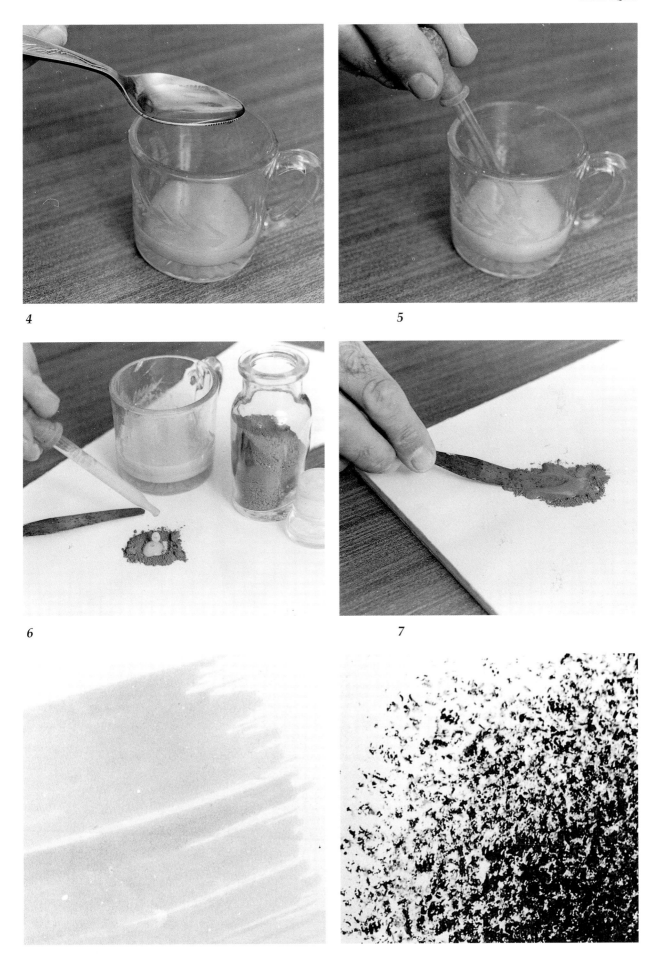

4

5

6

7

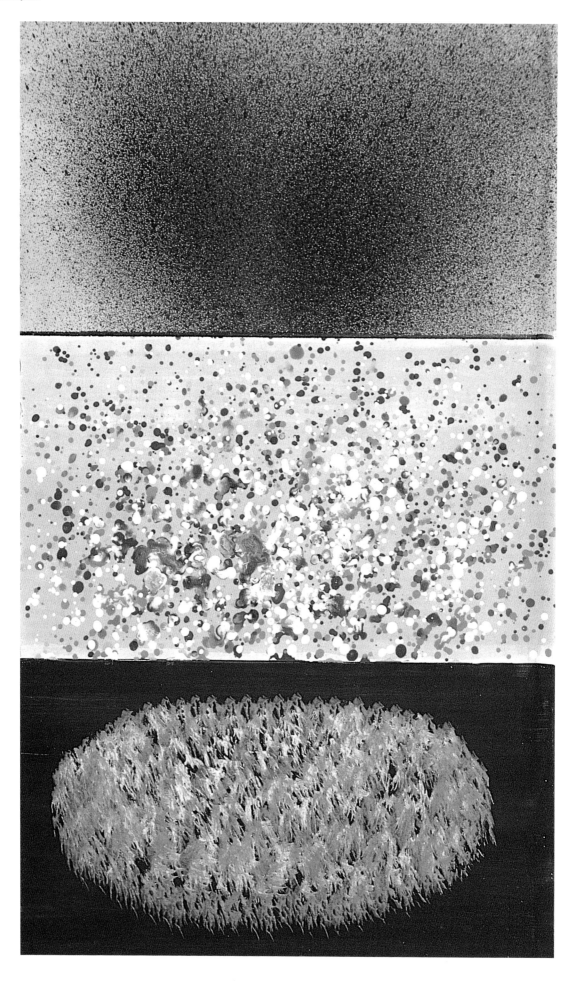

Above left
An interesting effect made by spattering with a
toothbrush. The specks are really fine and produce a
texture similar to that of an airbrush

Centre left
Flicking and spattering in the same way as with
watercolour, gouache and acrylic

Below left
Stippling with a no 11 drybrush

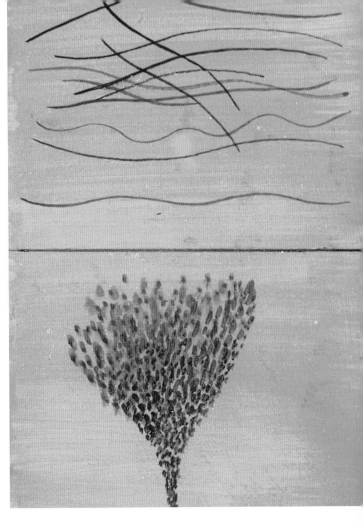

Right
Effects made with small brushes. Above, lines produced
with a no 000 brush. Below, a shape created by 'dabbing'
the bristle ends of a no 2 pointed brush

Right
Scratching with a fine steel blade made these marks as it
cut through the paint back to the gesso-coated board.
Differing colour of the 'lines' is due to the fact that there
are a number of layers of paint applied with a sponge.
Some marks are deeper than others, exposing a different
layer colour

Above
A 'wet into wet' technique. The paint was dribbled into a wet wash. Titanium white introduced into the texture created the 'milky' effect

Below
This little study grew from an accident. I painted a wash of raw umber mixed with alizarin madder which granulated, leading me to continue with a 'misty' image. Always keep an open mind!

STEP-BY-STEP
GUIDES

Now that we have looked at the range of materials that can be used,

and experimented with the various methods employed,

it is time to move onto a series of step-by-step guides,

designed to help you develop your skill and confidence in painting detail.

These have been grouped in four water-based media

– watercolour, gouache, acrylic and egg tempera –

but are not presented in any order of progressive complexity

LAST HINGES

Watercolour, 300x225mm

I could not resist painting this stable door which appeared to be on its last hinges. The colours and textures produced by the ravages of time proved to be a fantastic temptation. Having walked past it a few times, I finally got down to drawing it and gradually began to soak up the detail. The precarious tiles, above, were fascinating – one sneeze would have brought the whole lot tumbling to the ground! Hand-made bricks on either side of the door provided an excellent opportunity to produce the colour and texture of their individual characteristics. The door, having been painted black at some stage, provided a challenge. Black paintwork is always difficult to depict because it tends to be any colour other than black! Hopefully the problem was resolved as you will see in the later stages of the painting.

Below: the finished painting

COLOURS USED

*lamp black
cadmium yellow pale
crimson alizarin
raw sienna
burnt sienna
warm sepia
neutral tint
French ultramarine*

Surface:
Bockingford 250lb paper

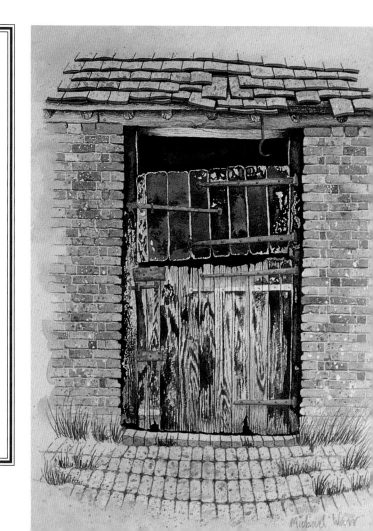

STAGE ONE

Masking fluid is applied on the lines of mortar and also flicked onto the tiles and bricks. Raw sienna is washed over the roof, wall and yard with a no 16 pointed brush. The beam and door are left dry at this stage. Whilst the raw sienna wash is damp a mixture of lamp black and cadmium yellow pale is fed into the roof tiles, also touches of crimson alizarin and burnt sienna, crimson alizarin, cadmium yellow pale, warm sepia and neutral tint are introduced into the brickwork using a no 8 pointed brush. These colours are allowed to dry.

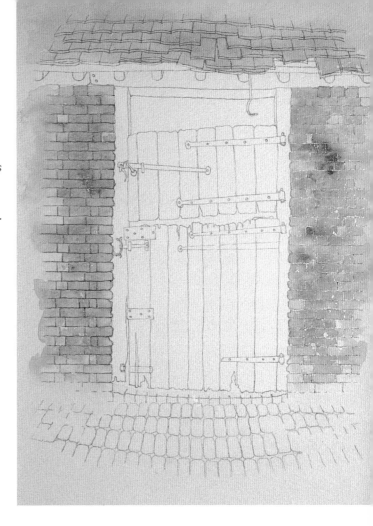

STAGE TWO

Darker green, pale crimson and cadmium yellow pale are spattered and flicked onto the tiles after removing the masking fluid. Warm sepia is added to the green and used for the dark edge of the tiles and the joins. The shadows are a strong version of cadmium yellow pale and lamp black. All the work is carried out with nos 1 and 000 brushes.

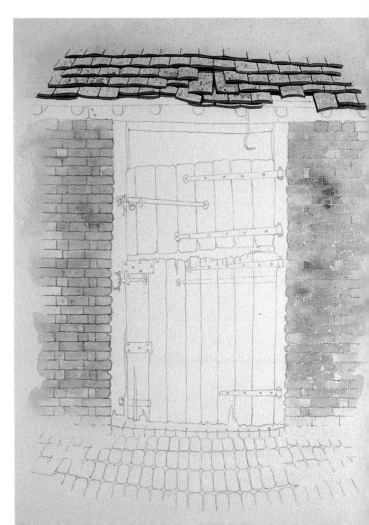

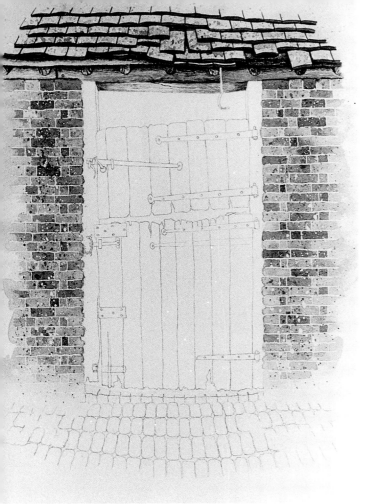

STAGE THREE

The eaves are now ready for attention and washes of dilute warm sepia mixed with burnt sienna and neutral tint are applied with a no 3 pointed brush. A mixture of cadmium yellow pale and lamp black is used for the area on the right, which has been exposed to the elements for some length of time. A little drybrushing is used to convey decaying wood and the woodgrain formation is painted with warm sepia and a no 000 brush. Some of the bricks are strengthened with mixtures of burnt sienna, crimson alizarin, cadmium yellow pale, warm sepia and neutral tint, using a no 3 pointed brush. Some of these colours are flicked and speckled onto the brickwork. These areas are allowed to dry and the masking fluid is removed. Note that the colour is pale at the base of the wall as vegetation will appear later on.

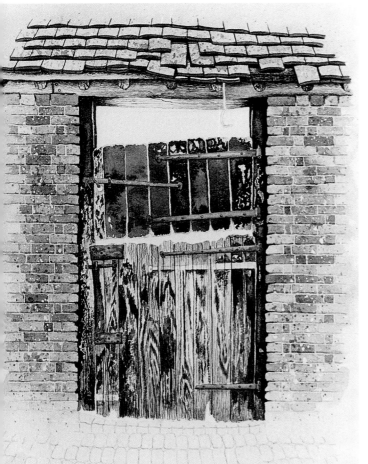

STAGE FOUR

Very dilute raw sienna is painted into the exposed mortar courses, now the masking fluid has been removed, with a no 000 brush. It is just enough to stain the white, exposed paper. Mixtures of warm sepia and neutral tint are used to suggest holes and crumbling mortar between the bricks and the same mixture is used for the shading underneath. The rusty door furniture is painted with mixtures of burnt sienna, cadmium yellow pale and warm sepia. As already stated, black paintwork is a challenge and neutral tint, in varying strengths, was chosen to portray the peeling black paint. This is lifted off in places because old black paintwork develops a 'bloom' rather like grapes. The green, stained areas are a mixture of cadmium yellow pale and lamp black. A no 000 brush and a mixture of warm sepia and neutral tint are used for the grain and joins in the wood.

STAGE FIVE

This stage commences with the completion of the hanging guttering bracket. The blue bricks at the bottom of the door are introduced with a mixture of French ultramarine and neutral tint whilst the same colours, with the addition of crimson alizarin, are used for the stone sets forming the yard. These colours are also speckled and spattered to suggest texture. The stone sets are not too detailed in order to allow the eye freedom to move up to the main subject – the door! Cadmium yellow pale mixed with lamp black, and applied with a no 000 brush, form the grasses growing between the stones and the base of the wall.

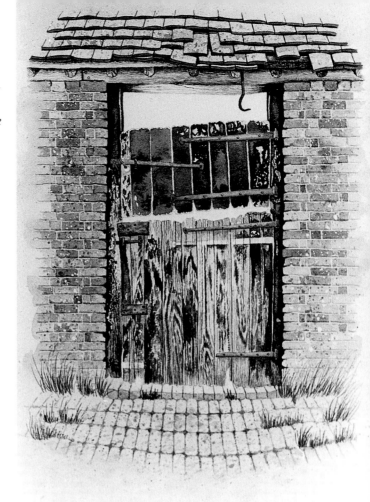

STAGE SIX

Finally the space behind the door is painted with a mixture of warm sepia and neutral tint.

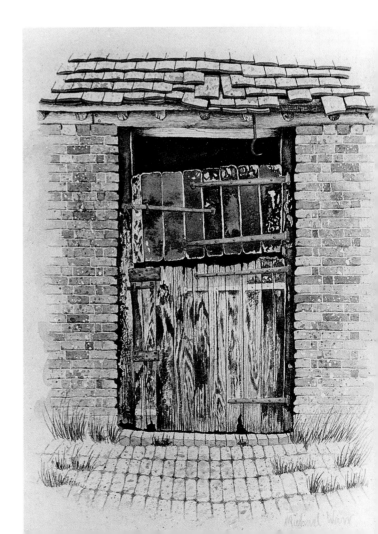

MOUNTAIN HUT

Watercolour, 250x300mm

This mountain hut was discovered in the Ticino, high up on the southern side of the Swiss Alps. Its remoteness and textures were the immediate attractions. The combination of pinewood and stone, obviously local materials, created a pleasing natural harmony in a picturesque setting. There did not appear to be a creature in sight and the solitude was fantastic. The silence in the mountains can be very eerie at times but on this particular day, with everywhere bathed in sunshine, all seemed to be at peace with the world.

COLOURS USED

monestial blue
French ultramarine
crimson alizarin
cadmium yellow pale
pale green
raw sienna
warm sepia
titanium white gouache

Surface:
Bockingford 250lb
rough paper

STAGE ONE
The main shapes are drawn with a 2B pencil, particularly the details of the building.

STAGE TWO
The paper in the sky area is dampened with clear water ready to take a mixture of monestial blue and French ultramarine. This is applied with a no 12 round pointed Dalon brush. The colour is applied fairly carefully allowing exposed areas of paper to form cloud shapes.
Whilst the sky area is drying masking fluid is drawn onto the detailed areas in the building with a no 000 brush. Masking fluid is used to mask joints between areas of stonework and the split stones on the roof, and is flicked and spattered onto stonework to produce a texture and 'glinting' effect.
The tops of the mountains are painted with a mixture of French ultramarine and crimson alizarin. Patches of snow remaining on the north-facing mountainsides are produced by painting around them leaving the white paper exposed. Use of masking fluid here may have produced too hard an edge around the shapes.
The lower parts of the mountains are painted with a mixture of monestial blue and raw sienna, this wash being allowed to merge with the still damp wash above. During the application of these washes, the painting is tilted away causing the paint at the top of the mountains to run and form a pleasing 'edge'. There is very little detail in this area, the merging washes producing a desired, slightly misty effect.

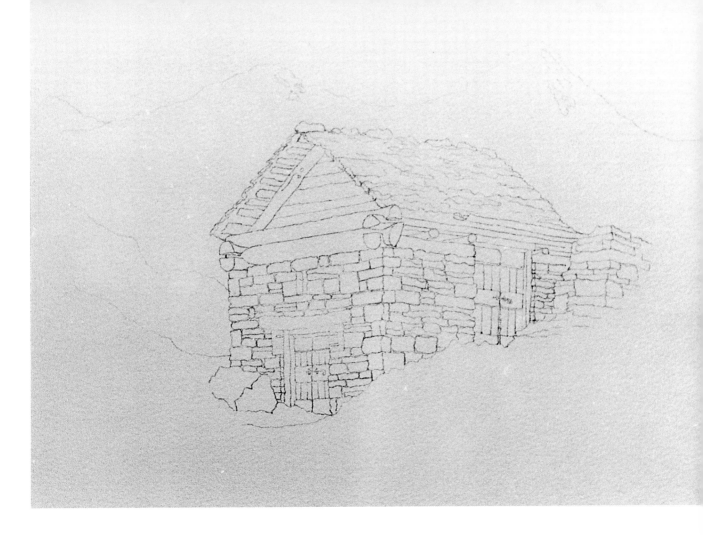

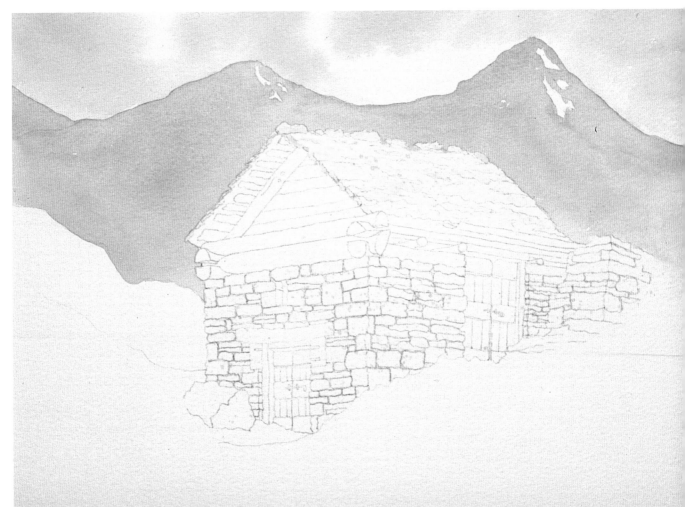

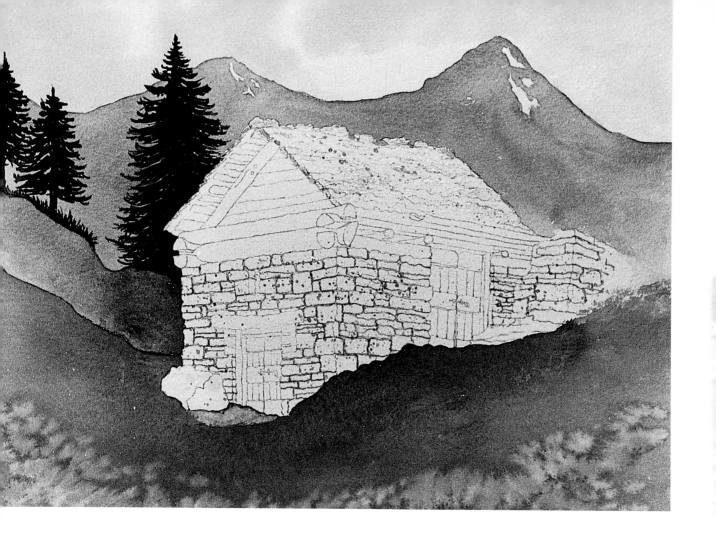

STAGE THREE

The pine trees are a mixture of monestial blue, cadmium yellow pale and raw sienna (a slightly stronger version being used for the tree directly behind the hut). The darker tones at the base of this tree help to push the hut forward. The ploy of using this technique is very often successful in this type of situation.

At the same time an initial foreground wash is added. It is a mixture of monestial blue and cadmium yellow pale, applied with the board tilted away to form an 'edge', particularly at the base of the building. The 'edge' on the extreme right-hand side is blotted away, allowing the wash to diffuse with the background. Later on vegetation will be painted into this area, linking the foreground to background. More texture is introduced at the base of the painting, being a mixture of titanium white gouache and cadmium yellow pale, fed into the existing damp wash.

There is a small area to the left of the hut, which is slightly different in colour. This depicts a section where haymaking has taken place; at this altitude they cut hay four times per year due to many hours of sunshine, and many inches of rain!

STAGE FOUR (Centre right)

The stonework and the roof of the building are painted in various mixtures of raw sienna, French ultramarine, crimson alizarin and warm sepia. When the washes are thoroughly dry the masking fluid is removed.

STAGE FIVE (Right)

Removal of the masking fluid leaves white areas of paper exposed and these are tinted with various mixtures of raw sienna particularly the joints in the stonework. A mixture of raw sienna and warm sepia is used to depict the wooden areas of the roof structure and also for the doors at the front and side of the building.

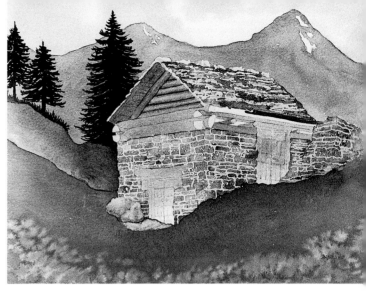

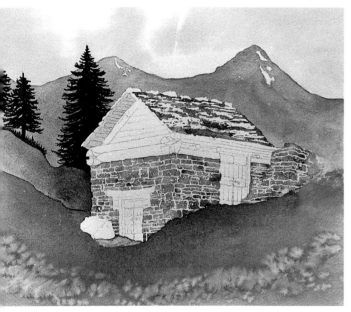

STAGE SIX (Below)

Dark tones and details are introduced into the roof using warm sepia. The grain and knots in the wooden area of the roof structure are painted with a mixture of warm sepia and French ultramarine using a no 000 brush.

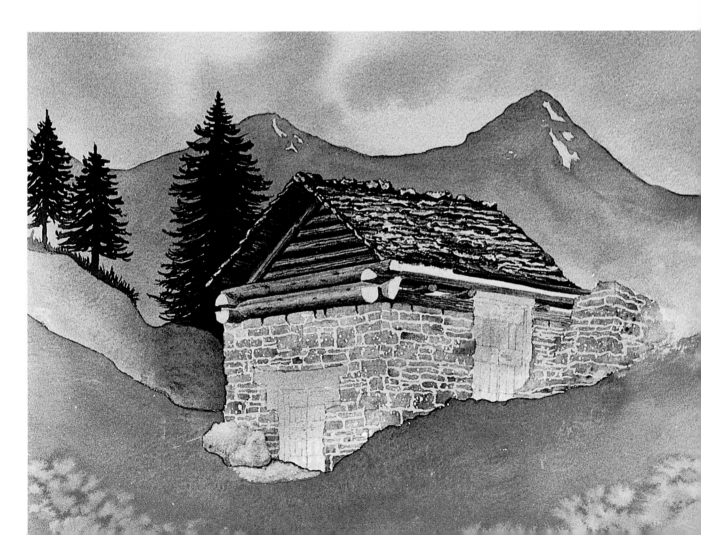

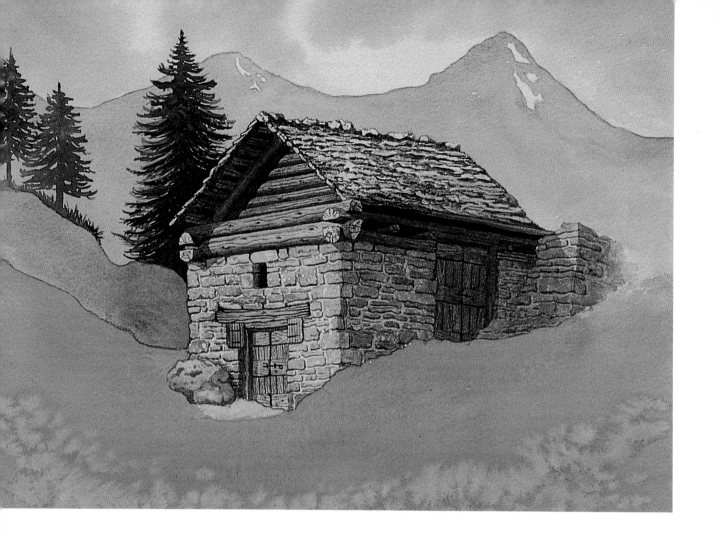

STAGE SEVEN

*Warm sepia, French ultramarine and a no 000 brush are
used to define the stonework. A stronger version of these
colours provides the dark tone which suggests the space
beyond the small breathing hole on the front of the
building.*

*The doors are overpainted with a stronger mixture of
warm sepia and raw sienna plus crimson alizarin. Grain,
knots, splits and various details are depicted with a no
000 brush and a mixture of warm sepia and French
ultramarine (see close-up detail opposite).*

*Strong warm sepia is used for the cast shadow under the
eaves whilst the shadow on the dark side of the building is
a mixture of French ultramarine and crimson alizarin.
The sunlit area on the wall to the rear of the building
echoes the light effect to be seen on the front.*

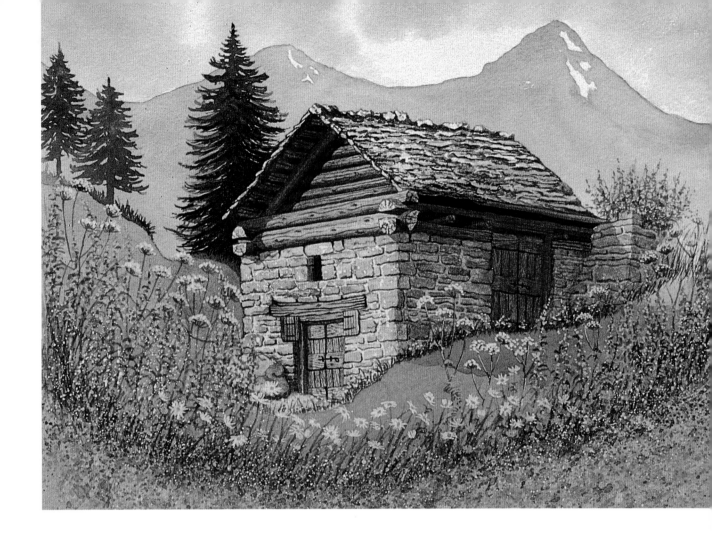

STAGE EIGHT

Rose-bay willow herb is seen growing out of a decaying wall to the rear of the building. The leaves are painted in two shades of green which are mixtures of French ultramarine and cadmium yellow pale. The flowers are a mixture of titanium white gouache and crimson alizarin. Dark green is used to suggest a cast shadow from the building on the right-hand side of the painting.

The foreground grasses are painted in with a no 1 pointed brush to provide a 'feel' to the area and a texture out of which taller cow parsley and rose-bay willow herb can grow. Greens are also flicked and spattered into this area to depict seed heads, leaves and general texture.

The cow-parsley heads are painted with titanium white gouache tinted with pale green, whilst as before the rose-bay willow herb is painted with mixtures of titanium white gouache and crimson alizarin. Ox-eye daisies appear, being neat titanium white gouache with centres of cadmium yellow pale tinged with crimson alizarin (see close-up detail). Other flowers were suggested by flicking and spattering titanium white gouache tinted with cadmium yellow pale, crimson alizarin and French ultramarine. The overall effect of this, hopefully, is that of an alpine meadow.

As the eye stumbles through the textured foreground, the curve in the grasses is used as a compositional aid, leading up through the trees, across the clouds and mountains, down through the rose-bay willow herb, finally concentrating attention onto the main subject. The painting contains both detailed and free-flowing passages which in landscape work can produce an interesting balance.

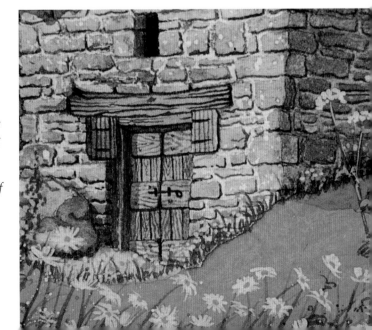

CLINKER BUILT

Watercolour, 140x220mm

The initial, exciting reaction to this subject came from the shapes, shadows and contrasting colours. Lying on its side, because of low tide, the boat presented a challenge from the drawing point of view. After having built a boat some years ago, their shapes and structures have always had a fascination for me. Understanding the structure of any chosen subject is always of great help when drawing or painting it. John Constable, the very fine landscape painter, studied the weather in order to help him make his cloud formations completely convincing in his paintings. To enable a complete understanding of subject matter, this kind of activity can be most useful.

COLOURS USED

rose d'ore alizarin
crimson alizarin
burnt sienna
raw sienna
French ultramarine
Paynes grey

Surface:
Bockingford 250lb paper

STAGE ONE

The distant sea-wall is painted first of all with a mixture of Paynes grey and raw sienna. This is an unusual composition as there is no sky but the dark sea-wall forms a frame for the picture. Paynes grey and raw sienna granulate when mixed together, creating a stone-like texture in the wall. Masking fluid is applied to the small boats in the background, inside the large boat where highlights are required and on the nearside gunnel where scuffing has taken place removing one or two layers of paint. A wash of raw sienna is applied to the beach area with the side of a no 11 pointed brush and the water is added using French ultramarine and Paynes grey. Paynes grey is also introduced into the area of beach which is still wet from the receding tide.

STAGE TWO

Masking fluid is removed from the background area and the small boats are painted in using burnt sienna and a no 1 pointed brush. The beach requires more attention and the distant area is strengthened with raw sienna mixed with burnt sienna. Moving through to the middle distance where there is wet seaweed and shingle, French ultramarine mixed with raw sienna is used, and then the dry shingle is painted with a no 6 pointed brush, moving horizontally, with mixtures of burnt sienna and raw sienna. There is a spattering of these colours in the immediate foreground.

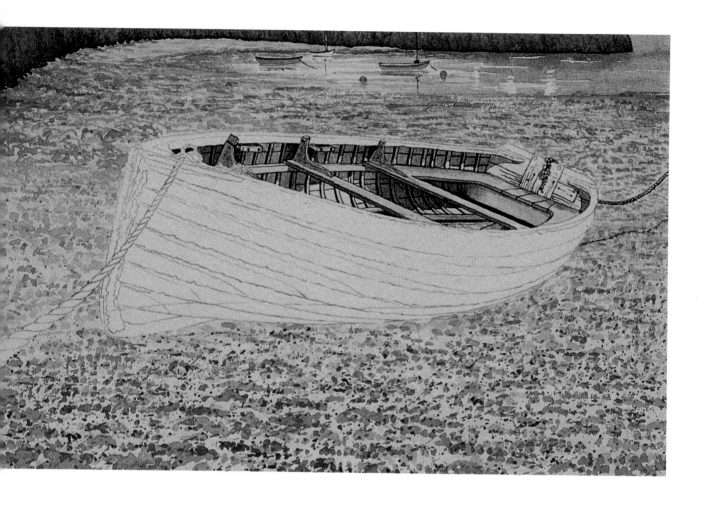

STAGE THREE

It is time to think about the boat and, because the inside is very light, it seems appropriate to tackle this area first. Masking fluid has already been used to mask out the highlighted areas as these are quite small in size and, in some instances, surrounded by dark shadows. French ultramarine mixed with crimson alizarin is used for these dark areas. The masking fluid is removed and a weak mixture of French ultramarine mixed with crimson alizarin is used to tint the lighter areas. Note that the paper in these very light areas is only just stained! It is most important to pay great attention to the highlights and details in shaded areas otherwise sunlit surfaces will not be convincing. The dark side of the struts are painted with a mixture of French ultramarine, crimson alizarin and a touch of Paynes grey. One or two other lines are also introduced suggesting planking on the inside and pieces of wood in the bottom of the boat. The seats are then tinted with a mixture of burnt sienna and Paynes grey. A no 000 brush is used throughout.

STAGE FOUR

Over the masking, which has already been applied to suggest scraping and scuffing, rose d'ore alizarin is painted onto the brightly coloured gunnels. A little burnt sienna is added to the shaded area on the nearside. Some of the areas on the stem are touched in with burnt sienna, where the damaged paintwork exposes the natural wood, and Paynes grey is used to define areas where filler has been used to repair damage. The 'painted' bottom of the boat is a mixture of burnt sienna and French ultramarine.

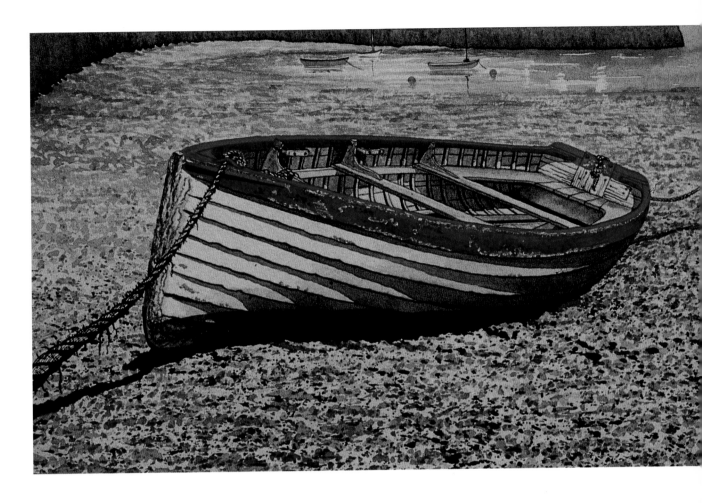

STAGE FIVE

Some of the colour at the base of the stem is redampened and blotted away to suggest scuffing and a number of damage marks are painted onto the white planking. The shadows on the planking are a mixture of French ultramarine and crimson alizarin whilst the shading is a weaker version of this mixture. When these areas are dry, the undersides of the planks are strengthened with a strong version of French ultramarine mixed with crimson alizarin and immediately underneath the boat the same mixture of French ultramarine and crimson alizarin is used. Paynes grey, applied with a no 000 brush, is used for the forward rope; a weaker version being used for the shaded parts. Darker colour, in the form of French ultramarine mixed with crimson alizarin, is flicked onto the beach in the foreground to suggest shadows of the shingle. It is applied in a horizontal direction, in order to retain the level of the beach.

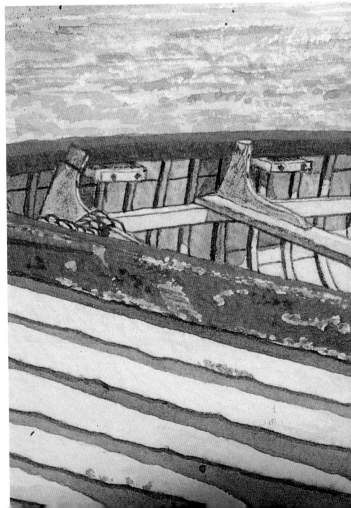

Right
Detail of Stage Five showing the exposed timber of the gunnel where the paintwork has been rubbed away, and also shadows of overlapping planks in the hull's structure.

BLESS THIS HOUSE

Watercolour, 315x252mm

This painting depicts the rear view of a terraced town house, of which there are tens of thousands in Great Britain. They were largely built at the turn of the twentieth century to house the workers during a boom in industrial output. Many of them originally had 'Bless This House' samplers on the living-room walls – pleasant reminders of grandma!

The perspective in this subject is very interesting and, at the same time, important to the overall conception of the painting. There is a dual tunnel effect: one formed by the chosen viewpoint, looking into the yard; the other being the passageway to the left. This type of subject provides an excellent exercise in the use of perspective and is particularly useful for training the eye to observe unfamiliar angles which may be encountered when the chosen viewpoint is in a confined area, very close to buildings. The change in perspective of the gate, incidentally, is brought about by the fact that it closes at an angle other than 90° to the house. The post on which the gate hangs is central to the passageway but the gate closes onto a post situated on the nearest wall.

Another very interesting feature is the passageway. This provides entry to the rear of this house and the adjoining one. The penetrating light at the far end comes through a window above the passage door; an extra dimension or depth is added to the painting at this point. There is light entering from both ends of the passageway, making it a fascinating subject in its own right.

Sometimes, showing the base of a building in a painting can produce a feeling of severity which can be unpleasant for the eye, but here it is necessary, although the moss at the base of the walls helps to soften things somewhat. The change in colour between the warm glowing bricks of the walls and the blue 'pavers' forming the yard is quite dramatic. This drama continues through the joints in the pavers as they zoom towards us! Incidentally the blueness in the yard is echoed above in the blue bricks forming arches above the passageway and large sash window. The brickwork of the walls tends to be in urgent need of repointing. Holes where the mortar has eroded and crumbled causes textures and shadows, an interesting point when drawing and painting older buildings.

To bring a splash of colour into these backyards the occupants very often plant a few flowers. Nasturtiums are a common favourite as they will grow in small amounts of poor soil and need very little light. Finally the vignette effect surrounding the painting seemed appropriate as it suggests a feeling of fond memories.

COLOURS USED

raw sienna
burnt sienna
crimson alizarin
French ultramarine
Paynes grey
neutral tint
warm sepia
cadmium yellow pale

Surface:
Waterford 200lb rough paper

STAGE ONE

After the initial drawing, masking fluid is applied to the courses of mortar in the brickwork and is also flicked onto the surface to produce texture, highlights and glints on the bricks. Masking fluid is also flicked and spattered onto the blue pavers. A no 0 round pointed brush is used for this purpose. The masking fluid dries and a very dilute raw sienna is washed over the entire painting. This not only helps with the required vignette effect but acts as a unifying factor because, in this case, the subject matter could easily become very 'bitty'. An overall wash appears to tie the composition together in a satisfactory manner. Stronger raw sienna is fed into the brickwork area as the dilute wash of raw sienna dries.

STAGE TWO

The brickwork area is redampened and burnt sienna is lightly applied producing a 'warming' effect. An initial wash of French ultramarine and crimson alizarin is introduced into the arches above the passageway and large sash window. The same colour is used for the blue pavers which form the yard. A very dilute version of this colour is applied to the fence boards, the gate and the manhole cover. Paynes grey is added to this dilute colour, and used for the guttering, underside of weatherboarding and returned brickwork to the left of the large sash window.

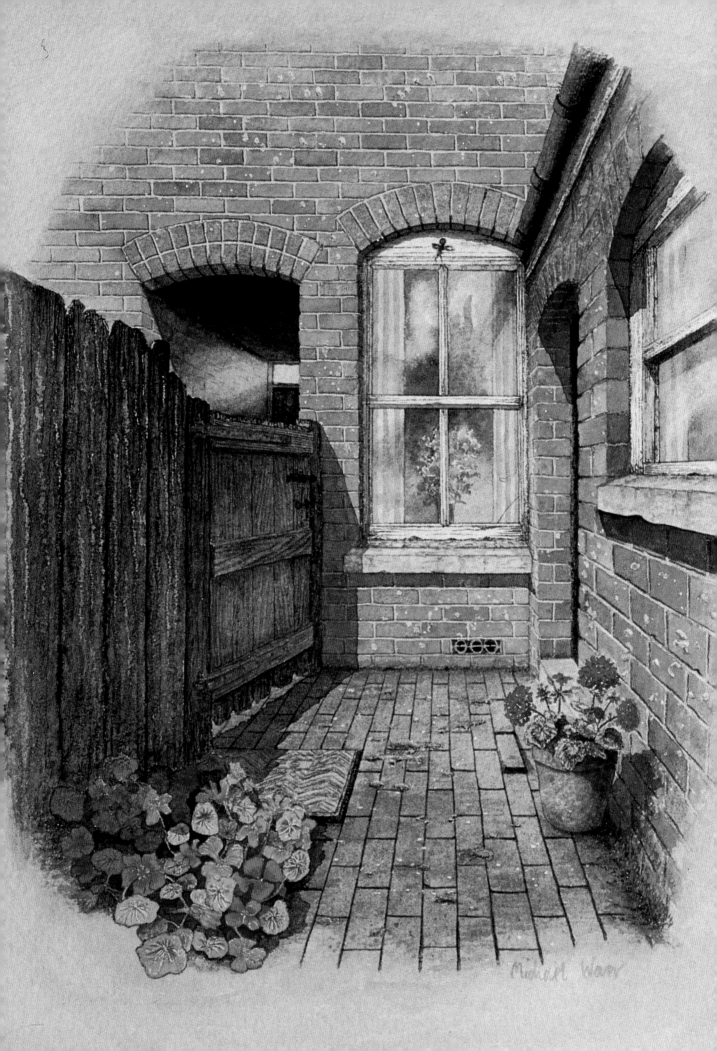

STAGE THREE

The individual bricks are now strengthened with mixtures of burnt sienna, raw sienna, French ultramarine, crimson alizarin and warm sepia. Joints between the yard pavers are painted in very lightly using dilute Paynes grey. These will be overpainted with a stronger version of the colour at a later stage. After checking that all of the areas are thoroughly dry, the masking fluid is removed.

STAGE FOUR

Very weak raw sienna is introduced into the mortar joints with a no 1 round pointed brush, followed by a mixture of Paynes grey and raw sienna to provide texture and shadows of the bricks. A no 000 brush is used for this. Stronger Paynes grey is drybrushed over a wash of the same colour for the very narrow back-door space. Moss and short tufts of grass are added at the base of the walls with a no 0 brush and a mixture of cadmium yellow pale and French ultramarine. Joints between the pavers are darkened with a stronger version of Paynes grey and the moss and lichen on the yard are painted in with cadmium yellow pale and French ultramarine. There is some drybrushing to give them a little texture. Stronger Paynes grey is added to the manhole cover.

Left
The finished picture after completion of Stage Eight.

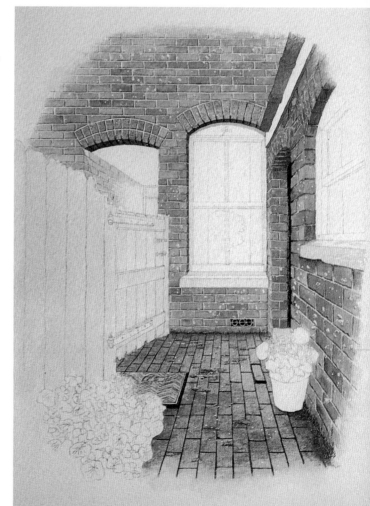

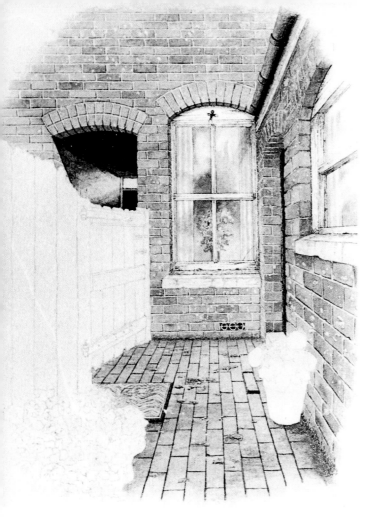

STAGE FIVE

Paynes grey is used to strengthen the guttering, both in the form of a wash and drybrush. Dark tones are introduced into the passageway using a mixture of warm sepia and neutral tint. Note the 'blotting off' effect where the light penetrates the door's window at the end of the passageway, causing diffused light to fall onto the adjacent wall. Reflections seen in the window panes are added, using mixtures of French ultramarine and crimson alizarin, with touches of neutral tint depicting darker tones, suggesting depth in the rooms beyond. The curtain linings are painted with dilute raw sienna and the reflections which appear to be in front of the curtains are also completed. Details are added to the windowframes with a no 000 brush and Paynes grey. Touches of green, which are a mixture of cadmium yellow pale and French ultramarine, are added to the windowsills and those parts on the windowframes which have been exposed to excessive amounts of rainwater over the years.

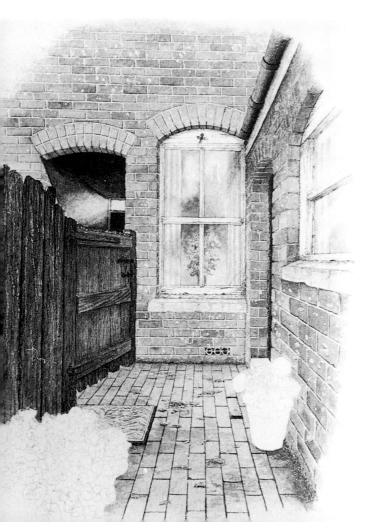

STAGE SIX

Another wash is added to the fence and gate, being a mixture of French ultramarine and burnt sienna, knifing out the grain shapes before the wash dries. The joins in the fence, and grain formations both in the gate and the fence, are introduced using mixtures of Paynes grey and warm sepia. Green stains are washed on with a mixture of cadmium yellow pale and French ultramarine. A mixture of burnt sienna and warm sepia is used for the rusty gate hinges and burnt sienna alone for the rust stains on the woodwork.

STAGE SEVEN

The terracotta pot is now painted using a mixture of warm sepia and burnt sienna, blotting out with tissue to suggest light grey staining which forms on this type of pot. French ultramarine is mixed with cadmium yellow pale to suggest the green staining. Mixtures of crimson alizarin and cadmium yellow pale are used for the geraniums, whilst the leaves are a mixture of French ultramarine and cadmium yellow pale, with a touch of Paynes grey added to the same mixture for markings on the leaves. The leaves of nasturtiums have very light veins, so masking fluid is applied here with a no 000 pointed brush. The nasturtiums themselves are painted with various mixtures of crimson alizarin and cadmium yellow pale, whilst the leaves are a mixture of French ultramarine and cadmium yellow pale. The masking fluid is removed and the leaf veins are lightly tinted with dilute raw sienna. Any spaces between the leaves are depicted with mixtures of French ultramarine, cadmium yellow pale and warm sepia.

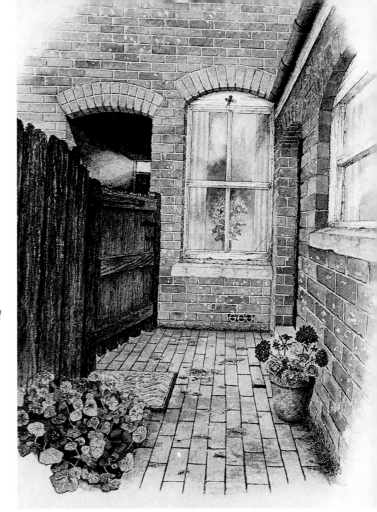

STAGE EIGHT

Finally the shadows are added by using a weaker mixture of French ultramarine and crimson alizarin.

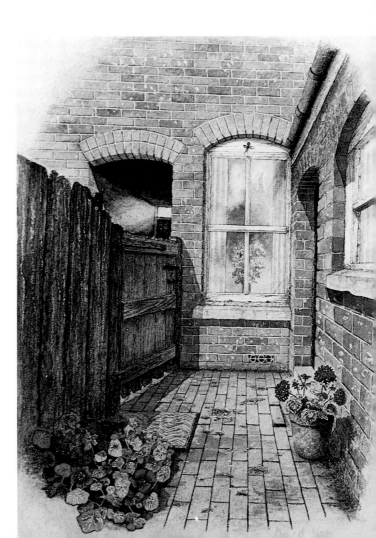

AT THE READY

Drybrush Watercolour, 365x240mm

These snowshoes were found at a farm and were immediately seen as a painting subject. The negative shapes formed by the intertwining ropes were fascinating, as were the woodgrain and contortions of the webbing. Subtlety in the colours, and also the angle at which they were hanging, were further great attractions. Snowshoes are used to spread the load of the feet when walking on deep, fresh snow and are most useful to farmers in the mountain districts particularly if livestock needs attention in an emergency; hence the title of the painting.

STAGE ONE (Right)
Here we see the drawing on the watercolour paper, ready to take the paint.

Below
The finished picture after the completion of Stage Eight.

COLOURS USED

raw sienna
burnt sienna
cadmium yellow pale
Paynes grey
French ultramarine
warm sepia
neutral tint

Surface:
Whatman 200lb rough paper

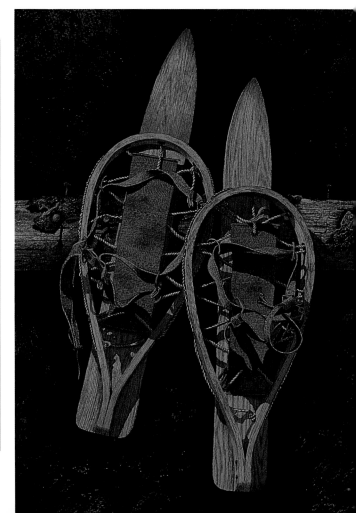

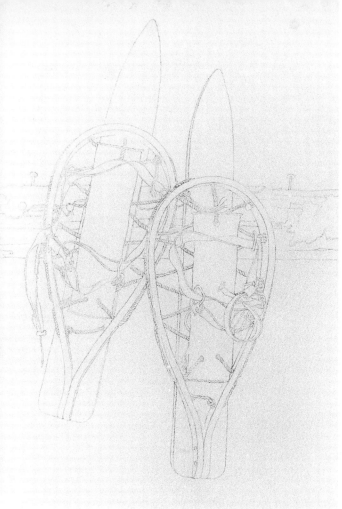

STAGE TWO (Above right)
Work begins in earnest on the round beam, on which the snowshoes are hanging. An initial wash of raw sienna mixed with burnt sienna is applied with a no 8 pointed brush. Over this wash mixtures of cadmium yellow pale, French ultramarine and a little burnt sienna are drybrushed to suggest the green staining effect, and other areas are treated with stronger burnt sienna and burnt sienna mixed with warm sepia. A no 2 pointed brush is used for this, whilst a no 000 brush is used to paint in the marks, cracks and splits with a mixture of warm sepia and neutral tint.

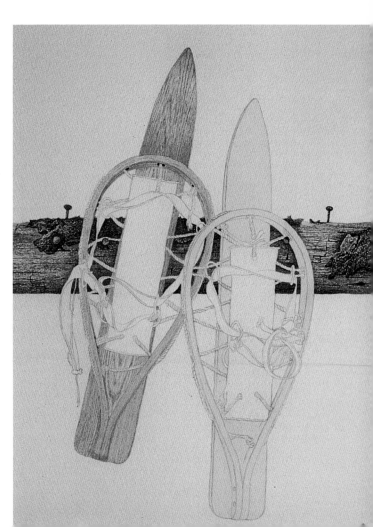

STAGE THREE (Right)
The bark is added using Paynes grey and cadmium yellow pale with touches of warm sepia. The beam is now complete and a wash of dilute raw sienna with a touch of Paynes grey is applied to the wooden parts of the snowshoes. Over this wash the woodgrain is painted with a no 000 brush and a mixture of Paynes grey and raw sienna. Careful observation of the grain formation is important at this stage.

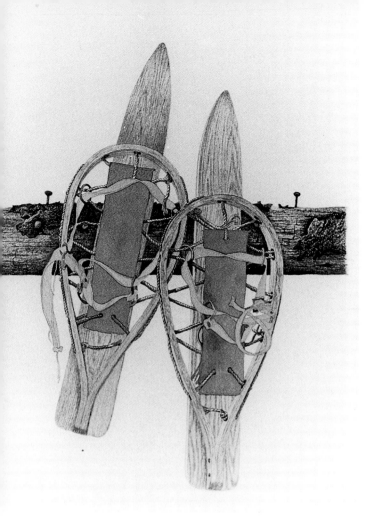

STAGE FOUR

The second snowshoe is treated in the same way and the ropes are painted using a no 000 brush with a mixture of Paynes grey and raw sienna, the shading being a weaker version of these colours. Washes are applied to the webbing consisting of Paynes grey mixed with raw sienna. The actual straps are painted in a lighter tone at this stage because they have an edge which needs to remain very light in parts. Paynes grey, in various strengths, is used for the buckles and rings but a little burnt sienna is added to the buckles, here and there, to suggest slight rusting.

STAGE FIVE

The webbing is completed by drybrushing a stronger version of Paynes grey mixed with raw sienna over the underlying wash of similar colour.

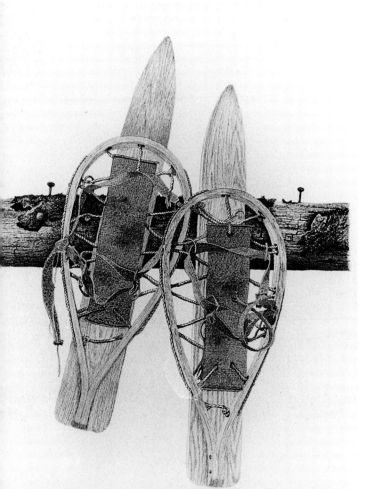

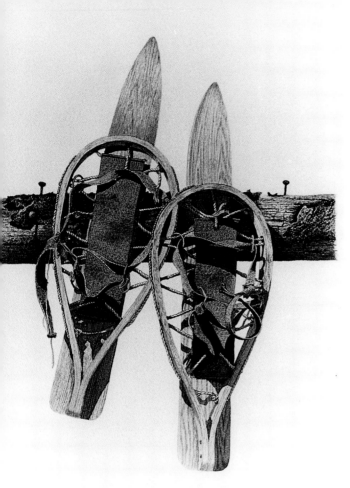

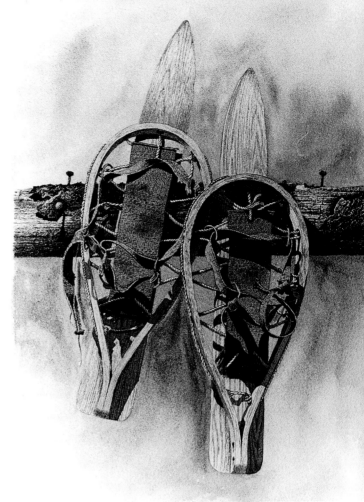

STAGE SIX (Above)
Cast shadows are painted in the form of a wash. Warm
sepia is used on the beam, a mixture of warm sepia,
Paynes grey and raw sienna for the snowshoes, and a
stronger version of these colours for the webbing.

STAGE SEVEN (Above right)
Washes of raw sienna, burnt sienna and warm sepia are
introduced into the background area using a no 11
pointed brush in the large areas, and a no 1 pointed
around the details.

STAGE EIGHT (Right)
A mixture of warm sepia and neutral tint is drybrushed
over the luxurious washes underneath with a no 6
pointed brush. The colours of the previous wash are
allowed to show through, suggesting texture, because, as
with Drying Beauty on pp74-5, it is space which is
being depicted.

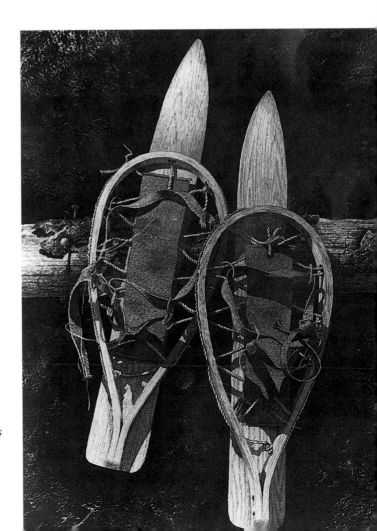

DRYING BEAUTY

Drybrush Watercolour, 395x245mm

The drying, everlasting flowers in this painting are helichrysums. Originally natives of South Africa and Australasia, they are grown locally by the wife of a farming friend. In fact, these particular ones were discovered in the old dairy of their farm, near to my home. The flowering period is normally late August through to late September and, after picking, the flowers are hung up to dry. During the winter months when fresh flowers are unobtainable their bright colours add life to a room, and they can be seen in a variety of arrangements from complete baskets to just a few heads in a small bowl. The brittle, dry helichrysums lend themselves to the drybrush method of painting.

STAGE ONE

The shapes are drawn in carefully, particularly the flower formations, which consist of many sharp, brittle petals. These need to be exact, in order to produce the convincing dry, brittle effect which is required. A weak mixture of Paynes grey and raw sienna is washed onto the areas depicting the wooden beam and the stems of drying flowers. A slightly stronger version is used for the darker underside of the beam. The cracks and splits, including the small ones around the knot formation, are painted with the same mixture. Being rusty, the nails are treated with a dilute mixture of warm sepia and crimson alizarin.

STAGE TWO (Right)

Over the initial, luxurious wash of Paynes grey and raw sienna, a stronger version of these colours is used to portray the grain formations. The paint is applied with a no 000 and no 1 brush. There are touches of French ultramarine added to Paynes grey washed on here and there to suggest stains, scratches and marks. Some of the stains are simply a wash of raw sienna. Stronger Paynes grey and French ultramarine are used for the grain on the underside of the beam and over this a slightly stronger wash of Paynes grey mixed with raw sienna is applied. The large splits are painted with a mixture of warm sepia and neutral tint. These two colours, when mixed together and used strongly, produce a very rich, dark tone. It is necessary to ensure that the small wood particles retained in the large splits are depicted and, to be seen, they are allowed to remain light in colour. The nails need to be picked out, so a stronger version of warm sepia and crimson alizarin is drybrushed onto them.

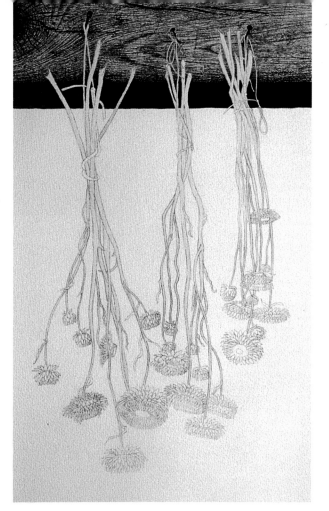

STAGE THREE (Below right)

As the stems dry out, they lose their original fresh green colour and become rather more muted in appearance. The fresh green changes to a brown-green and the tones up and down the stems vary considerably. The paint is used in varying mixtures of raw sienna and French ultramarine and is applied with a no 3 brush. A no 1 brush is used for the narrow parts and a no 000 brush is used to depict the 'lines' forming the slight grooves. Stronger French ultramarine mixed with raw sienna is used for this purpose.

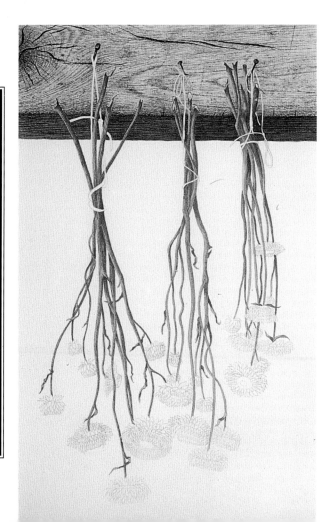

COLOURS USED

Paynes grey
raw sienna
French ultramarine
crimson alizarin
cadmium yellow pale
warm sepia
neutral tint

Surface:
Whatman 200lb rough paper

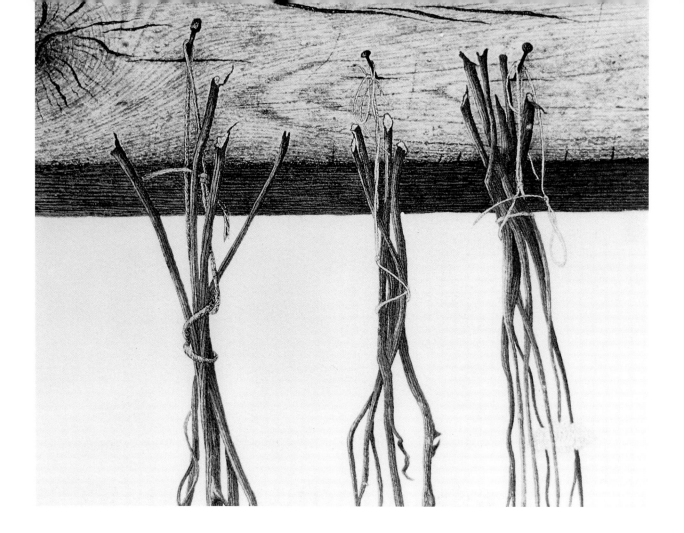

STAGE FOUR

*String is used to attach the drying flowers to the nails:
two pieces being similar and of the white twine type; the
third being old-fashioned brown parcel string. A weak
solution of warm sepia and a stronger version for the
thread weave are used for the latter, whilst weaker and
stronger versions of neutral tint are used for the two
pieces of white thread.*

STAGE FIVE

*The spiky, brittle flower heads are painted with various
mixtures of crimson alizarin for the crimson ones and
mixtures of cadmium yellow pale for the yellow ones. Just
to confuse matters, there is some of each colour in most of
them! The paint is applied mainly with a no 1 brush, but
a no 000 brush is used to define the spiky petal shapes. In
the case of the crimson flowers, crimson alizarin mixed
with French ultramarine is used for defining the shapes;
whilst a mixture of French ultramarine and raw sienna is
used for this definition on the yellow flowers. These two
colours are also used for the centres with just a hint of
speckled cadmium yellow pale.*

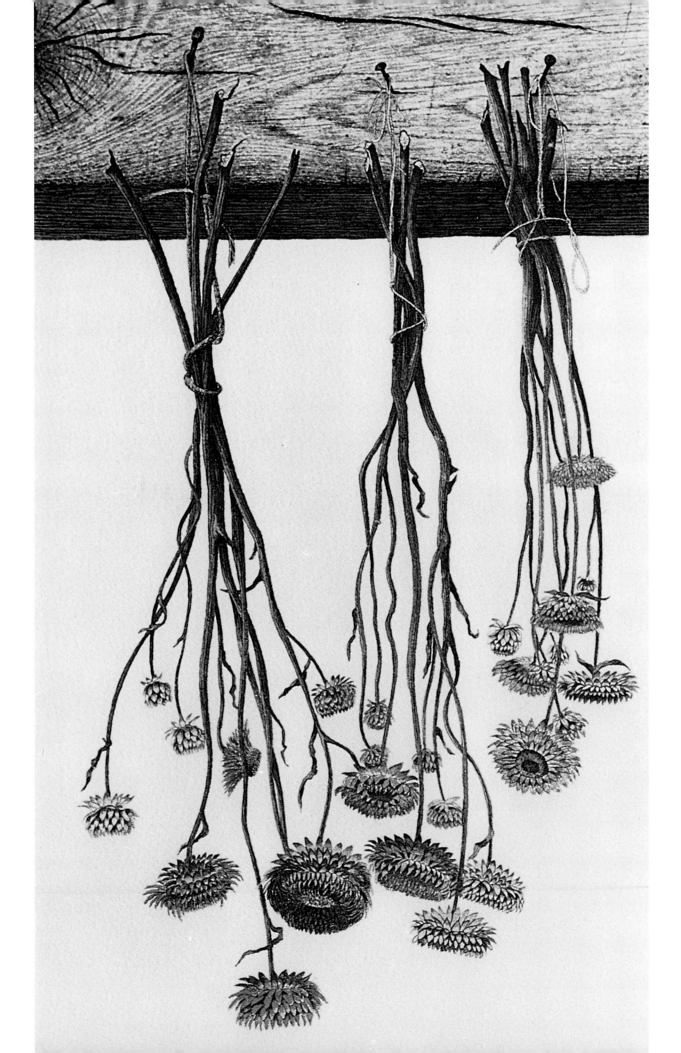

STAGE SIX

It is now possible to wash on some colour for the background. An initial mixture of warm sepia mixed with neutral tint is applied. The dark, rich colour produced evokes the dimly lit rural effect behind the main subjects. This colour is washed over the whole of the background area, being a little lighter at the bottom of the painting. It needs to be applied with care, and is rather a painstaking task, because it picks out the shapes between the stems and around the pointed petals. When this has dried a stronger mixture of the two colours is drybrushed over the complete background area. Texture is formed at the bottom, because the underwash is lighter. To produce texture behind the flowers themselves may cause visual confusion and so the colour here is rather more solid adding to the impact of the main subjects. The dry flowers are so brittle and light in weight, any slight breeze will make them twist and sway very gently.

Detail showing dark background colour in its initial stage

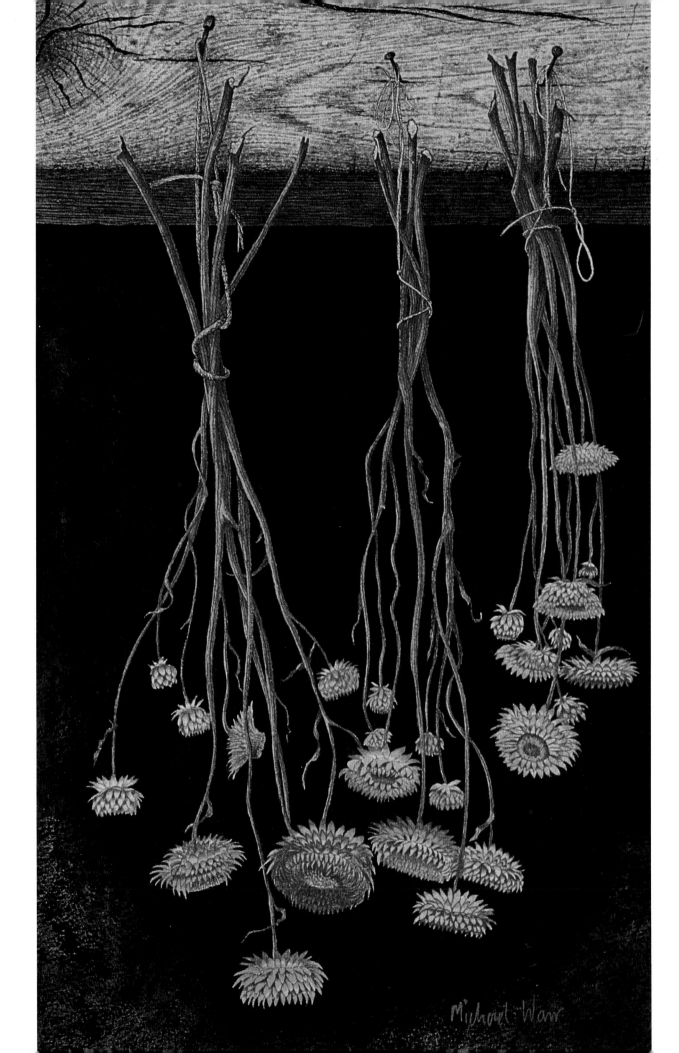

KERRY

Gouache, 150x190mm

From my studio, when it was at Nettle Hill Farm, this Kerry Hill sheep was often observed and drawn. The windows overlooked the sheep enclosure and this particular one, which was the only Kerry Hill, fascinated me. Arriving at Nettle Hill alone, the ewe was not able to lamb, and the owner there took pity on her. The cuddly dense fleece was most appealing adding to an overall neat shape. Black markings on the white face and white markings on the black legs provided more interest increasing the desire to make a painting of the subject!

COLOURS USED

yellow ochre
lemon yellow
burnt sienna
French ultramarine
crimson alizarin
titanium white
ivory black

Surface :
Whatman 200lb rough paper

STAGE ONE
The sky and bushes are applied in the manner of traditional watercolour, wet into wet, causing a merging of the two subjects. French ultramarine, very dilute, is used for the sky whilst mixtures of French ultramarine, burnt sienna and lemon yellow are used for the bushes.

STAGE TWO
A wash is introduced into the field consisting of lemon yellow and French ultramarine. Whilst this wash is still damp crimson alizarin is added to the resulting green and gently introduced into the foreground. Then, again into this wash, small dots of neat titanium white pigment are added. An interesting texture appears because the strong pigment spreads as it comes into contact with the damp surface, creating star-like shapes. Some acrylising medium is added to a mixture of burnt sienna and French ultramarine and applied to the sheep's body. The reason being that later on lighter, opaque colour will be added to depict the fleece and dark shapes will be allowed to show through, suggesting texture and layers of wool. Acrylising medium 'fixes' the dark gouache, enabling further layers to be added without the dark colour 'picking up'. This can be one of the drawbacks of using gouache.

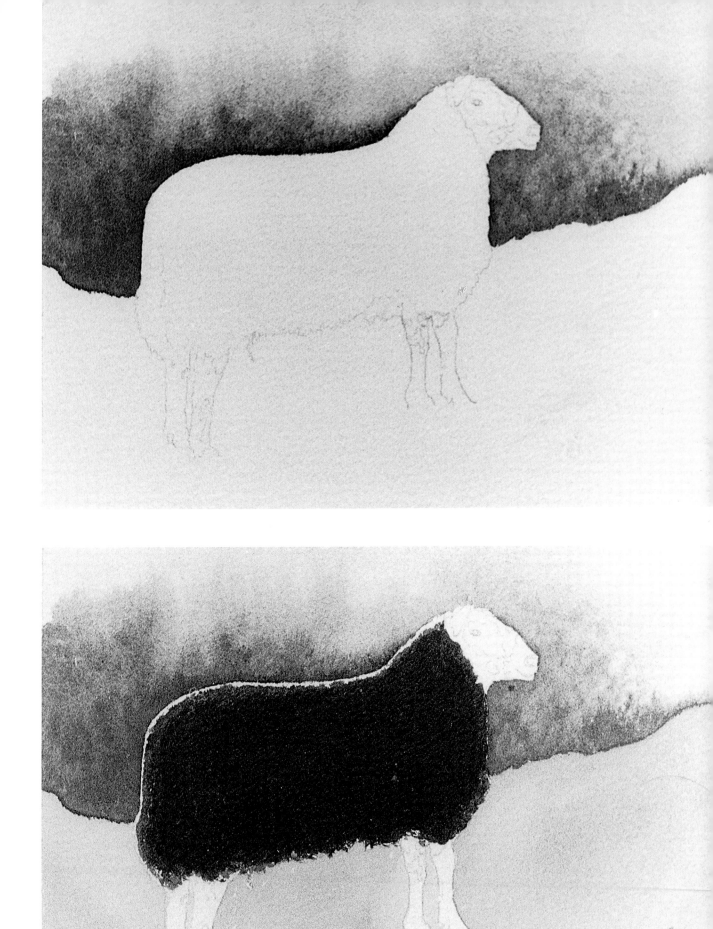

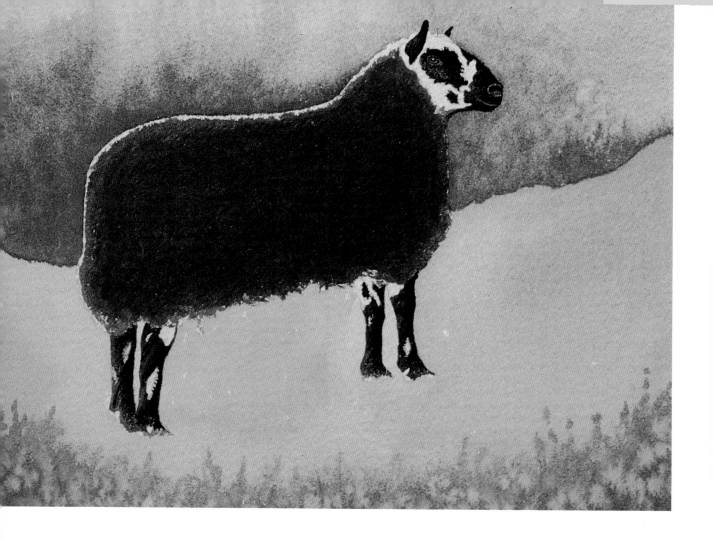

STAGE THREE (Above)

Facial features are next on the agenda. The black areas are painted with a mixture of ivory black and French ultramarine whilst neat titanium white is drybrushed onto the white areas. Mixtures of yellow ochre, French ultramarine and burnt sienna are used for the eye and painted in carefully with a no 000 brush. Dilute titanium white is washed over some of the black areas, suggesting sheen and highlights. This technique is very useful when suggesting shine or sheen on the dark areas of a subject. The legs are painted in, using the same technique and colours as for the face.

STAGE FOUR (Above right)

The detail is painted into the field, working from the far side to the foreground in a horizontal manner. A no 1 brush is used to apply mixtures of lemon yellow, French ultramarine and titanium white in a series of fine vertical strokes, the paint remaining fairly dry. Dipping into various mixtures of these colours provides variety, rather than one monotonous colour, and it is important to load the brush generously at frequent intervals. The flowers in the background are painted with crimson alizarin and titanium white.

STAGE FIVE (Below left)

This is the stage when the opaqueness of the medium is really exploited. A few light lines are painted onto the body of the sheep to suggest the wool flow. Then a mixture of fairly thick titanium white and yellow ochre is drybrushed over the dark underlay. Remember it is fixed, so that there is no danger of the dark paint picking up. The colour is applied with a no 2 pointed brush and some of the dark areas underneath are allowed to remain exposed.

STAGE SIX (Below)

Drybrushing continues on the fleece with titanium white and yellow ochre, the intensity changing in certain areas to suggest tonal differences. The very dark tones in the fleece are mixtures of burnt sienna and French ultramarine.

Foreground grasses are introduced with a no 1 pointed brush and greens, yellows, pale blues and titanium white are flicked on with a no 6 pointed brush. These bright colours help to intensify the sunlit feeling in the painting from the compositional point of view. Note the space allowed for the subject on the right-hand side. It is a good idea to let the subject look 'into' the picture, rather than cutting the picture off and thereby stifling the subject.

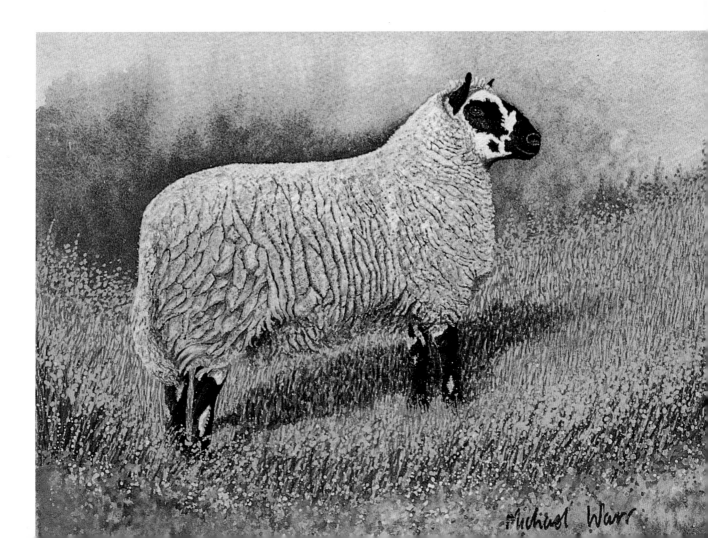

Michael Warr

ALPINE DAISIES

Gouache, 214x138mm

Marguerites or ox-eye-daisies can be found all over the world. These particular ones were in the alpine region of Switzerland. Their bright 'faces' always attract me; they look so white and fresh in the mountains, seen against a darker background. In this instance the petals of the two foreground daisies overlap, giving a feeling that they are holding hands for support amongst the taller ones. Gouache on dark green paper was chosen to depict light colour against dark.

STAGE ONE *(Below left)*
Behind light drawing with a Caran d'Ache white pencil, grasses are painted very loosely with mixtures of yellow ochre, French ultramarine, burnt sienna and titanium white, using a no 2 pointed brush.

STAGE TWO *(Right)*
The petals are painted with neat titanium white – one layer should suffice; this demonstrates the excellent covering power of gouache.

COLOURS USED

titanium white
yellow ochre
French ultramarine
burnt sienna
golden yellow
vermilion

Surface:
dark green paper

STAGE THREE

Stems, sepals and centres are painted with a no 1 pointed brush. Mixtures of golden yellow, French ultramarine and titanium white have been used. There is not very much detail at this stage, just basic shapes.

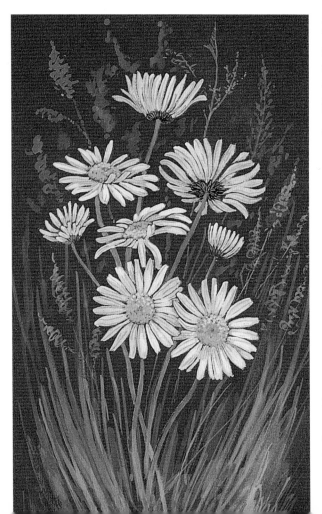

STAGE FOUR

The petals are completed by painting veins and shading with a no 000 brush and a mixture of French ultramarine, burnt sienna and titanium white. Detail is added to the sepals and the centres are strengthened with golden yellow, titanium white and a touch of vermilion. The green paper is allowed to show through, helping to create a 'seedy' texture.

STAGE FIVE (Right)

Light and shade is applied to the stems using golden yellow, French ultramarine and titanium white in various mixtures. Grasses are strengthened with yellow-green and spattering at the base adds life, completing the picture.

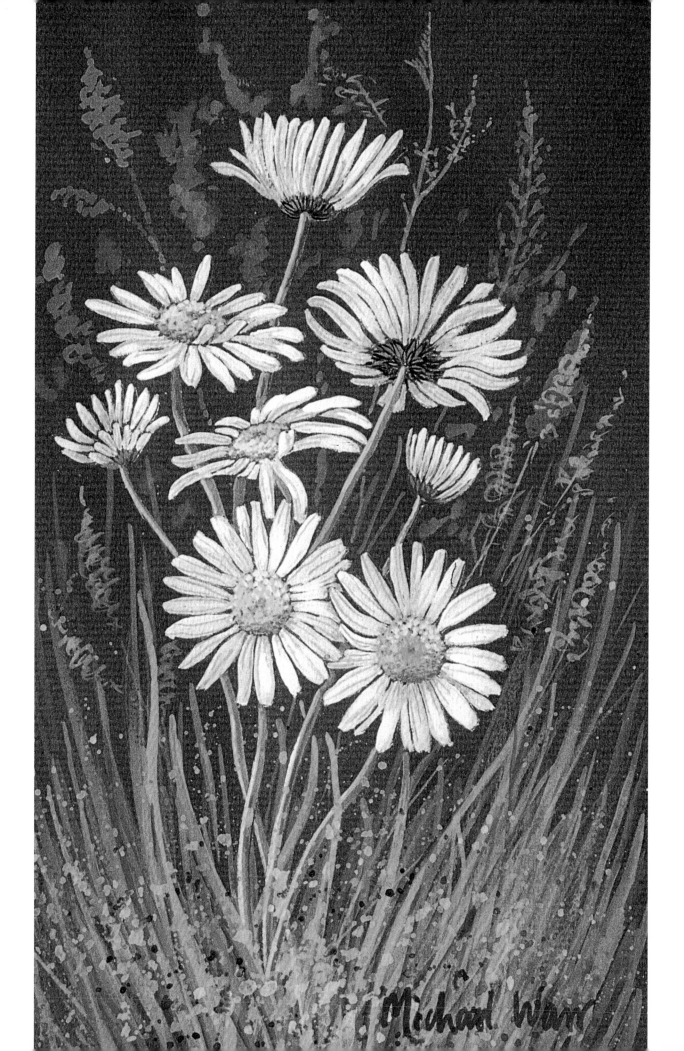

Michael Warr

BEETLE SCULPTURE

Acrylic, 335x255mm

Many a good subject can be found in a scrapyard and this VW Beetle manifold and silencer box is no exception. The piece has a totem-pole effect and, to my mind, evokes a sculptural feeling. The VW Beetle has become a legend throughout the world and this part offered texture, patina and an interesting collection of ellipses. As a new item, it may not have been nearly as interesting from the surface point of view. Finding it by chance at the rear of a garage near to my home proves that interesting subject matter can be found anywhere, so do not rule out the contents of your dustbin; there may well be a treasure trove of paintable subjects in there!

COLOURS USED

Venetian red
cadmium yellow
burnt sienna
raw sienna
burnt umber
Paynes grey
titanium white

Surface:
canvas painting board

STAGE ONE

Paint, diluted to a watercolour consistency, is applied over the whole painting. Being very dilute, it does not obscure the pencil-drawn lines, but provides a base on which to work. The main shapes are picked out, particularly the ones which are to become very dark. A series of colours, merging together, especially in the background, is applied with a no 8 pointed brush. Raw sienna, burnt umber, Venetian red and Paynes grey are the chosen colours.

STAGE TWO

The background, using a no 6 pointed brush, is stippled on, with mixtures of titanium white mixed with a little raw sienna. A creamy paint consistency is used now, making it rather more opaque. As this layer dries, colour is applied with a sponge using mixtures of burnt umber, titanium white and raw sienna. The background is completed by sponging on much lighter colour behind the manifold, retaining a 'high key' effect, enabling the main shapes to be seen clearly. A no 8 pointed brush is then used to flick dilute Paynes grey onto the same area. The piece of rusty sheetmetal, on which the main subject is standing, is painted with a sponge, and mixtures of raw sienna, Venetian red and titanium white, burnt umber and Paynes grey are applied here and there. The same colours are also flicked on, using a no 3 pointed brush. It is difficult to sponge right up to the broken, jagged edge, so a no 2 pointed brush is used to 'knit' the sponging into this area. Hopefully, the speckled, textured background echoes the textures of the rusty sheetmetal.

STAGE THREE

It is sometimes difficult to know where to start with main subjects, but the conclusion on this one was to start at the top and work down. Initially, work begins on the heat take-away box, which is manufactured from an alloy. Because of this, it is less prone to corrosion than some of the other areas, but there are traces of rust. A mixture of Paynes grey and titanium white is used for the light grey colour, whilst the corroded parts are treated with mixtures of Venetian red, burnt sienna and raw sienna. Nos 1, 2 and 7 pointed brushes are used to apply the colours.

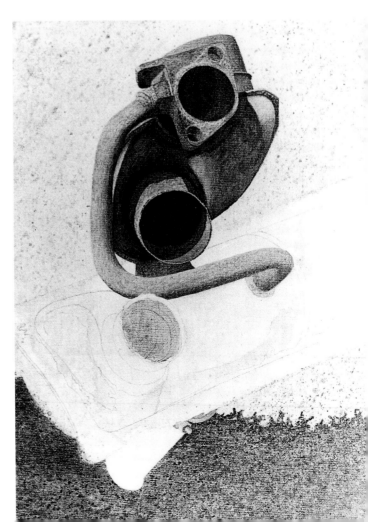

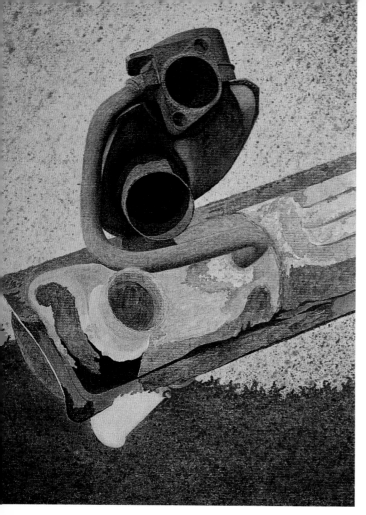

STAGE FOUR

Moving on to the rusty silencer box, flaking and peeling metal is painted with mixtures of burnt sienna, Venetian red, burnt umber and raw sienna and applied with the same brushes as in Stage Three. Paynes grey mixed with burnt umber are used for the holes caused by corrosion. The inside of the silencer box which can be seen is very dark because of the exhaust fumes that passed through it. Cadmium yellow is added to a mixture of burnt sienna and Venetian red to capture the orange rust colour. Note that there are small areas of the original light grey paint which are painted with mixtures of Paynes grey and titanium white.

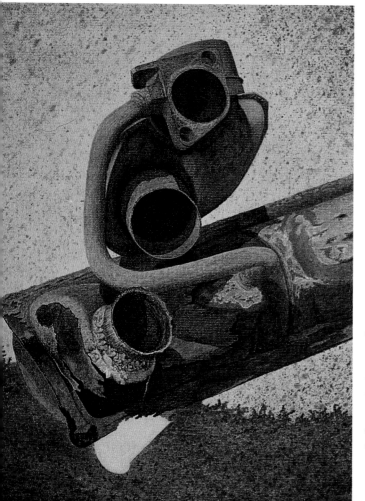

STAGE FIVE

Continuing with the silencer box, the finer detail is introduced using nos 1 and 2 pointed brushes with mixtures of the colours mentioned in Stage Four. Over these colours a very dilute mixture of Paynes grey and titanium white forms a glaze to produce a milky effect. This conveys the 'bloom' on the rusty metal and tones down the harsh colours. Even in this later stage, the paint is applied fairly thinly, allowing the texture of the canvas board to be retained; adding an extra textural quality to the painting. The silencer box is completed by adding the shadows, which are a mixture of Paynes grey and burnt umber.

STAGE SIX (Right)

A dilute wash of titanium white tinted with raw sienna is glazed over the rusty sheetmetal, providing a 'bloom' on the surface. The protruding exhaust pipe, which remains chromium plated, is painted with opaque titanium white and Paynes grey. Over this are glazed very dilute washes of Paynes grey and touches of raw sienna. A shadow of the whole shape is cast onto the sheetmetal, and this is finally added with a mixture of burnt umber and Paynes grey, using a no 7 pointed brush.

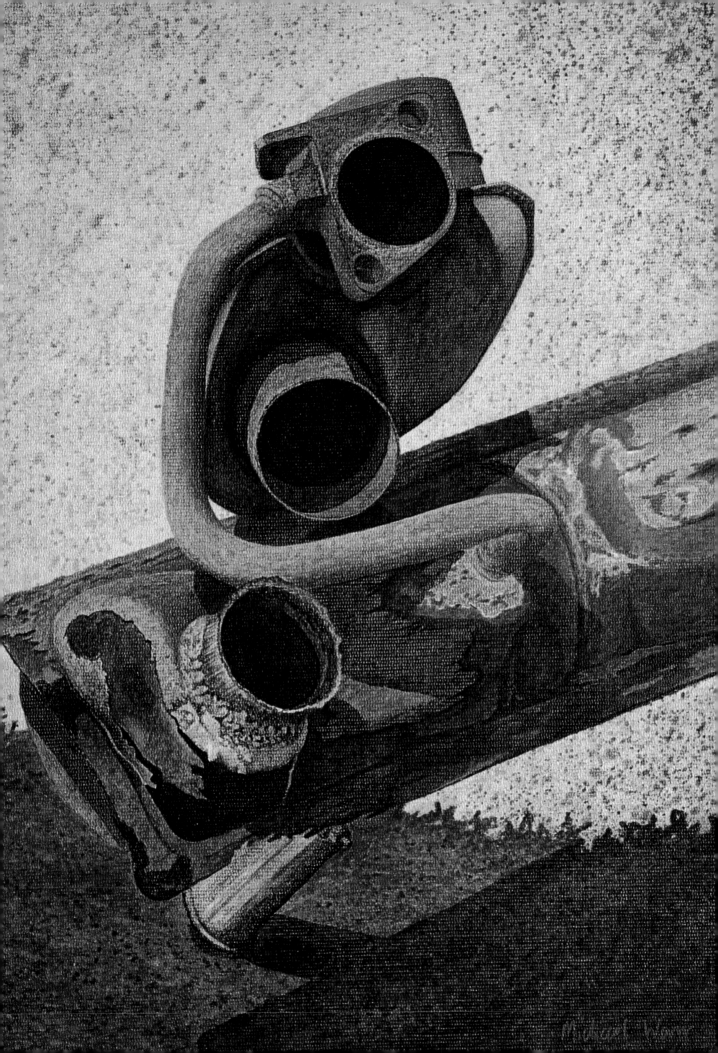

GERTCH

Acrylic, 250x200mm

I like colourful characters and this man is no exception! He lives in a valley in central Switzerland and readily agreed to allow me to make a painting of him. His lined face with bushy beard fascinated me, as did the knarled hand clutching his pipe, which emitted light blue-grey hazy smoke: a challenge to any painter. His furry jacket completed the array of textures just waiting to be depicted in a picture.

COLOURS USED

yellow ochre
burnt umber
opaque oxide of chromium
French ultramarine
Paynes grey
cadmium scarlet
Venetian red
titanium white

Surface:
gesso on high-density fibre board

STAGE ONE
Three layers of paint, a mixture of burnt umber and Paynes grey, are stippled to form the background with a no 3 pointed brush.

STAGE TWO

The hat is painted with mixtures of burnt umber, opaque oxide of chromium, yellow ochre and titanium white. After initially applying the paint with a no 3 pointed brush, finer texture is stippled with a no 000. A wash of yellow ochre is used for the hatband, over which detail is depicted with a no 000 brush and burnt umber mixed with Paynes grey.

The lines on the face are painted first, with burnt umber and a touch of Paynes grey with a no 000 brush. After this a wash of yellow ochre is applied over the whole face. A mixture of burnt umber and Paynes grey is used for the shaded part whilst over the initial wash of yellow ochre, lighter areas are built up with mixtures of cadmium scarlet, yellow ochre and titanium white (a touch of burnt umber is added to the mixture for the darker tones). Notice that the cast shadow helps to accentuate the form of the face.

STAGE THREE

It is necessary to paint the shirt before the beard because fine, lightly coloured hairs are seen in front of very dark shadow. Two light layers of cadmium scarlet are used for the basic colour of the shirt followed by stripes painted with mixtures of cadmium scarlet, Venetian red and titanium white. Burnt umber mixed with Paynes grey and a touch of Venetian red is used for the cast shadow of the beard; the fine, wispy shapes are painted with a no 000 brush.

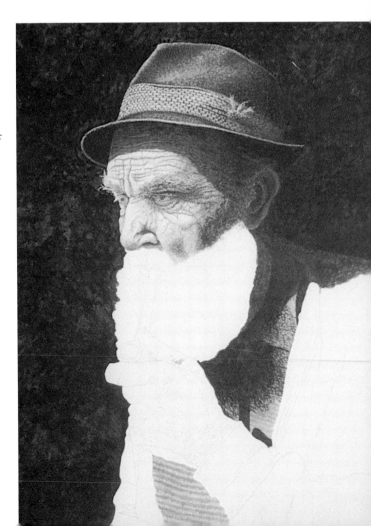

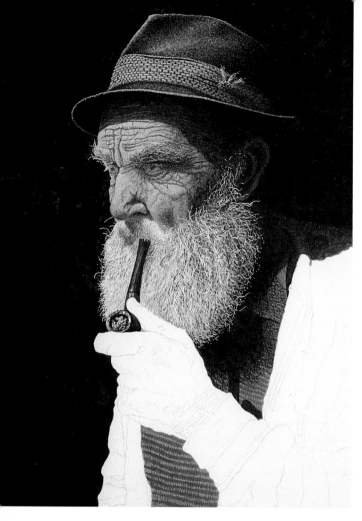

STAGE FOUR

Underpainting of the beard is carried out with light washes containing mixtures of yellow ochre and burnt umber. The pipe is underpainted with a dilute mixture of Paynes grey. A fine steel blade is used to scratch in the hairs of the beard, going right back to the gesso, resulting in a completely white effect. Dilute yellow ochre, burnt umber and Paynes grey are then used to tint the scratched lines, being darker here and there to suggest shape and form. The stem of the pipe is overpainted with a stronger version of Paynes grey, and the bowl with a mixture of Paynes grey and burnt umber. Ash in the pipe is completed with touches of cadmium scarlet to suggest red-hot burning tobacco.

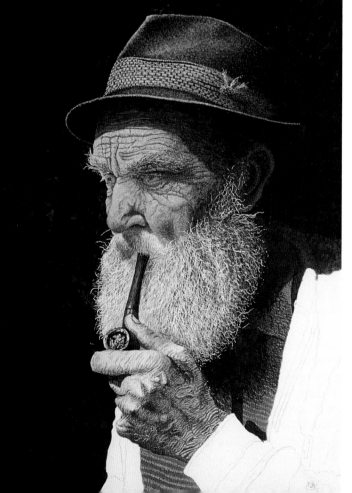

STAGE FIVE

It is now time to consider the hand, and similar colours are used to those in the face. Light underpainting is carried out in the same way over lines which have been painted with burnt umber and a no 000 brush. The fingers are overpainted with mixtures of yellow ochre, titanium white and a touch of cadmium scarlet. Burnt umber, yellow ochre, titanium white and cadmium scarlet are used for the back of the hand which is in slight shadow and therefore darker in tone. Light hairs are scratched in with a fine steel blade and then lightly tinted with yellow ochre.

STAGE SIX (Right)

The jacket is treated with a light upon dark effect. A mixture of Paynes grey and a touch of titanium white is painted over the whole jacket in a flat opaque manner. Over this, mixtures of yellow ochre, Paynes grey and titanium white are stippled with a no 3 pointed brush to obtain the furry look ; when this dries, a no 1 pointed brush is splayed and a weak version of Paynes grey mixed with burnt umber is applied over the complete area, introducing a little more texture. The smoke is depicted by using a no 2 pointed brush and weak mixtures of Paynes grey, French ultramarine and titanium white.

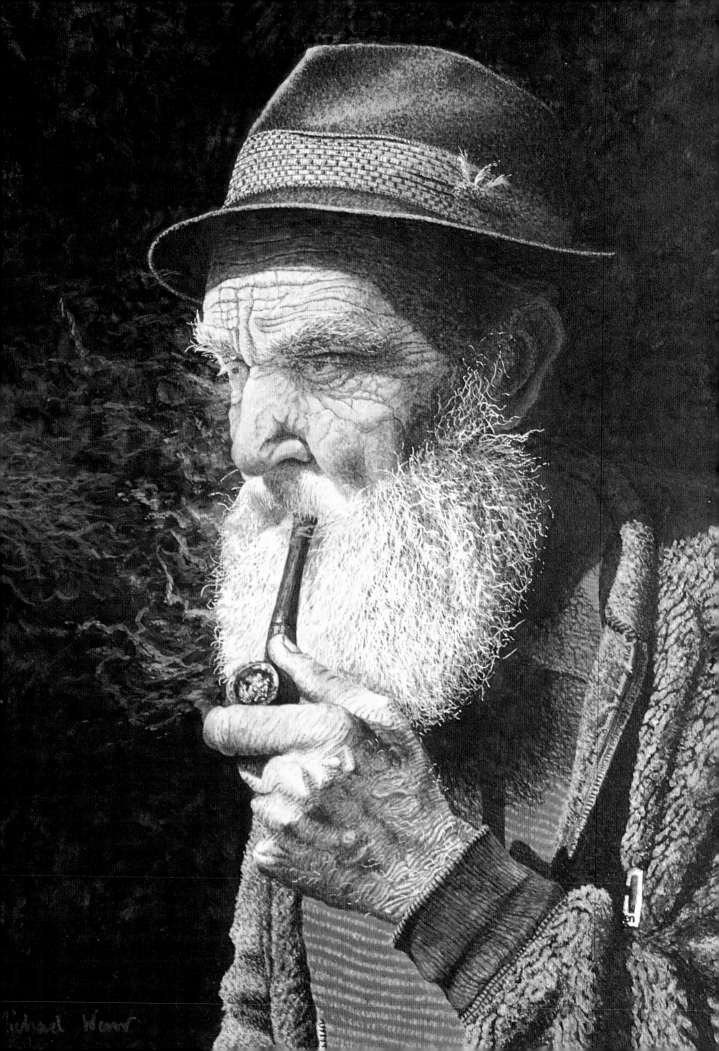

HENRY

Egg Tempera, 152x152mm

Pets make ideal subjects for detailed painting because their outward appearances can be so varied and interesting. The textures and colours they display can be a real challenge. They normally rest or sleep for reasonable lengths of time, enabling the viewer to observe and scrutinise the natural shapes and patterns. In the case of a domestic pet, observing, drawing and painting the subject can very often take place in the warmth and comfort of a kitchen or living-room, thus ruling out the necessity of tramping off for miles, or freezing to death in the pursuit of a suitable subject.

Henry is a tabby cat who is looked after by two friends of mine. This painting was commissioned by them, and offered a particular challenge because of his subtle colour and beautiful markings. Remember, painting is a problem-solving exercise which we set for ourselves and any subject which enables us to 'stretch' our knowledge of painting technique is invaluable.

COLOURS USED

French ultramarine
burnt umber
yellow ochre
Hansa yellow deep
titanium white
red ochre

Surface:
gesso-coated board

STAGE ONE
A wash of yellow ochre mixed with titanium white is applied to the background, whilst the cat receives the dark tones which are to become the stripes and markings. These are a mixture of French ultramarine and burnt umber, with touches of red ochre and yellow ochre mixed with titanium white being used for the nose and inside of the ears. The eyes receive their first layer of dilute Hansa yellow deep and French ultramarine. The basic shapes on which to build are now there.

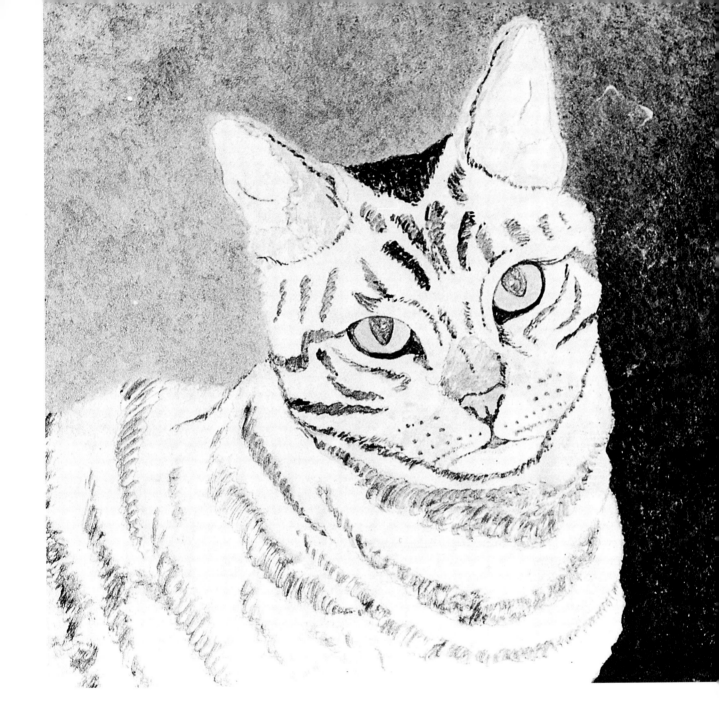

STAGE TWO
The background is more or less completed by stippling on paint with a no 3 round pointed brush. The colours comprise various mixtures of burnt umber, yellow ochre, French ultramarine and titanium white. Light and dark areas are produced for reasons which will be discussed later. A little more colour is washed into the lighter areas of the cat, providing useful underpainting at this stage.

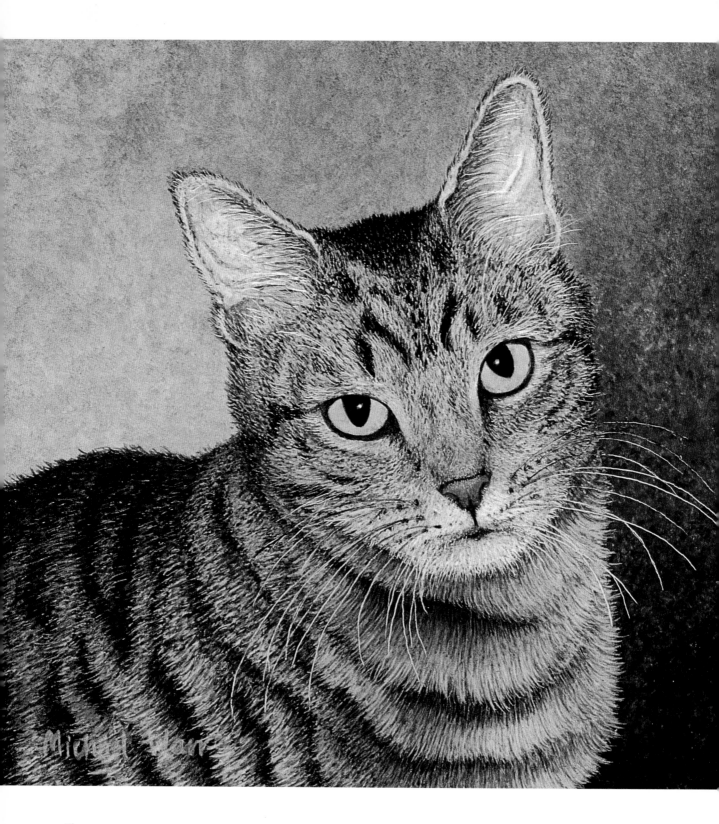

Above
The finished painting after Stage Eight

STAGE THREE

Just to confuse matters titanium white is painted over the whole area of the cat, except the eyes. The overall tonal value was not correct, and it was necessary to 'lose' the dark stripes until they were only just visible. Sometimes, of course, it is necessary to make these adjustments as the painting proceeds. First decisions are not always the right ones!

Starting again, the dark stripes are painted using a fairly strong mixture of burnt umber and French ultramarine and the lighter areas, at this stage, with a dilute version of the same colours. A little red ochre mixed with yellow ochre and titanium white is used for the neck, front and also the nose. The insides of the ears are strengthened with dilute French ultramarine with just a touch of burnt umber. Slightly darker colour is added to the whisker holes and the shapes around the eyes are strengthened. The eye 'slits' are not the correct colour yet, but these will be adjusted at a later stage.

STAGE FOUR

With a no 000 brush, the areas between the dark stripes are painted using a weaker mixture of French ultramarine and burnt umber. Fine brush strokes are introduced over the whole of the body and head to suggest darker hairs. These provide useful underpainting at this stage. Areas around the whisker holes and the top of the nose are painted with burnt umber and a touch of red ochre.

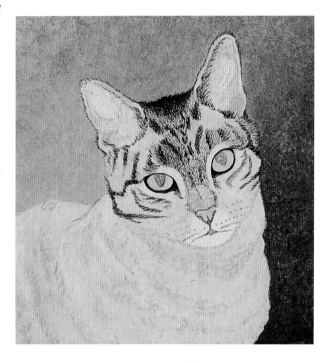

Below
A close-up detailed section of Stage Four shows the closely controlled brush strokes

STAGE FIVE

Fine brush strokes are added over the complete area of the cat, using mixtures of Hansa yellow deep, French ultramarine and titanium white, creating the overall colour effect of the desired yellow grey-green. Dilute red ochre mixed with Hansa yellow deep is added to the chest to suggest the slight ginger areas.

STAGE SIX

Strengthening the stripes begins again, using a strong mixture of French ultramarine and burnt umber. Dark marks are added here and there with the same mixture and lighter marks are introduced using neat titanium white, tinting it with very dilute mixtures of French ultramarine, Hansa yellow deep and red ochre. The hairs in the ears are developed using mixtures of French ultramarine, Hansa yellow deep, titanium white, French ultramarine and burnt umber. A no 000 brush is used for this purpose. Titanium white, with a touch of burnt umber and French ultramarine, is used to strengthen the 'white' area around the mouth.

STAGE SEVEN

It is now time to return to the dark stripes and dark accents making slight final adjustments with French ultramarine and burnt umber. Details around the nose and mouth are added with touches of Hansa yellow deep and red ochre; the brick-red nose leather being a mixture of Hansa yellow deep, red ochre and burnt umber.

STAGE EIGHT

It is now time to think about the eye slits again and these are darkened using a mixture of French ultramarine, Hansa yellow deep and burnt umber. The whisker holes are darkened and the whiskers themselves added by scratching with a fine blade. The parts of the whiskers nearest to the face are tinted with a no 000 brush and a very dilute mixture of burnt umber and French ultramarine.

The background is always important in any portrait or still life painting and here it is used to good effect by playing off a dark part of the cat against a light section of background; note how the darker area of background is useful to show off the light whiskers. It is very easy to treat the background in a painting as simply a 'backcloth' rather than allowing it to become an integral part of the whole.

LAST OF THE AYRSHIRES

Egg Tempera, 405x505mm

This painting of a cow and calf was prompted by the fact that a dairy farmer friend of mine was retiring. He was very proud of his Shilton Ayrshire herd which stemmed back to the early forties. Obviously it was necessary to run down the herd slowly and these two were sadly the end of the line. Seeing them against a man-made breeze-block wall seemed to give them a poignancy; their natural shapes were well defined in the light of the low winter sunshine. It seemed a fitting tribute to record them in the form of an egg-tempera painting.

COLOURS USED

lamp black
French ultramarine
red ochre
burnt umber
yellow ochre
Hansa yellow deep
titanium white

Surface:
gesso on board

STAGE ONE
After very light initial drawing, dilute titanium white is applied over the board, followed by a wash of French ultramarine, lamp black and titanium white to depict the shadow of corrugated iron from above. A dilute mixture of burnt umber, lamp black and titanium white is used for the ground area which is a slurry-covered concrete yard. Dilute washes are applied to the main subjects consisting of red ochre, burnt umber and yellow ochre; the mixture for what will be cast shadows is French ultramarine and burnt umber.

STAGE TWO
The courses of cement between breeze-blocks are indicated with a weak mixture of French ultramarine and burnt umber. Light spattering is applied at the base of the wall. Burnt umber and French ultramarine are used to depict the first layer for the shadows of the main subjects. A weaker mixture of these colours is stippled over the ground area followed by yellow ochre mixed with titanium white applied with the end of a flat wash brush. Another wash of French ultramarine and burnt umber is added to the shadow at the top of the wall.

STAGE THREE

Returning to the wall, a point worth remembering is not to repeat the textures and marks on the blocks. Each one is unique complete with its own characteristics – it is easy to dash through this type of subject and repeat oneself – careful observation is needed! At the same time it must not be overworked otherwise there is a danger of becoming trite. The winter sunshine is low in the sky, the light source, therefore, is slightly above and to the right. This side lighting effect creates an awareness of the vertical joints between the blocks. The horizontal joints have a slight angle, picking up more light than the verticals. Shadows under each block are strengthened using a mixture of French ultramarine and burnt umber, whilst the blocks are speckled and spattered with the same mixture conveying holes, hollows and cracks etc. Spattering at the base of the wall is intensified to depict real splashes and general grime. At this stage yellow ochre is added to the burnt umber and French ultramarine mixture. The pattern marks on the blocks forming the base are scratched in with a steel blade and strengthened on the left side with a painted dark line.

STAGE FOUR (Above right)

Using a series of fine strokes with a no 000 brush the hides of the cow and calf are painted with mixtures of red ochre, burnt umber, yellow ochre and titanium white. The cast shadows are introduced using a mixture of French ultramarine and burnt umber in the white areas. There is no texture yet, just flat areas of colour.

STAGE FIVE (Right)

Texture is suggested in the shadows with stronger mixtures of French ultramarine and burnt umber using a no 000 brush. To complete the white areas the very fine hairs, which are seen against dark tones, are scratched in with a fine blade. The cow and calf are now virtually complete; there will be final adjustments, particularly to the legs as the ground area is yet to be completed.

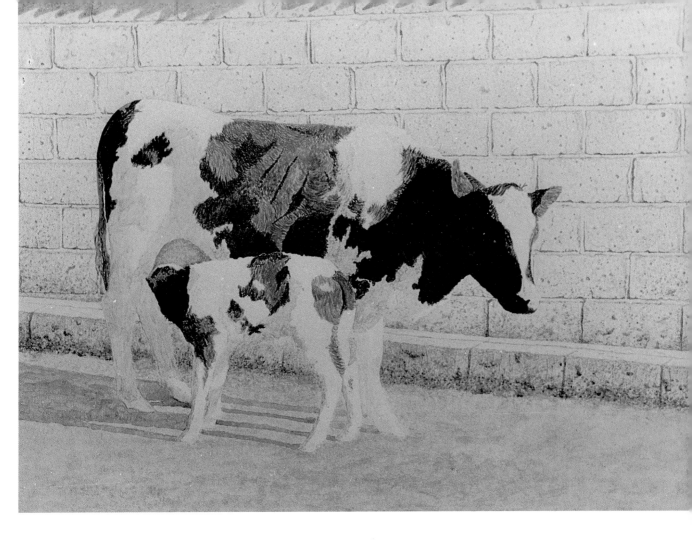

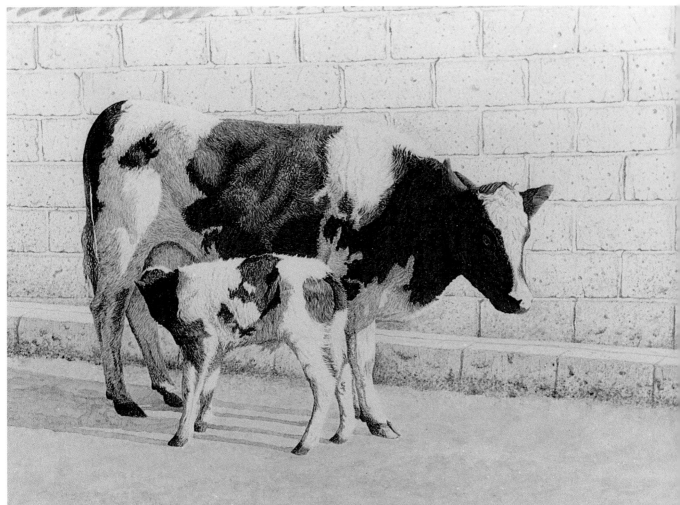

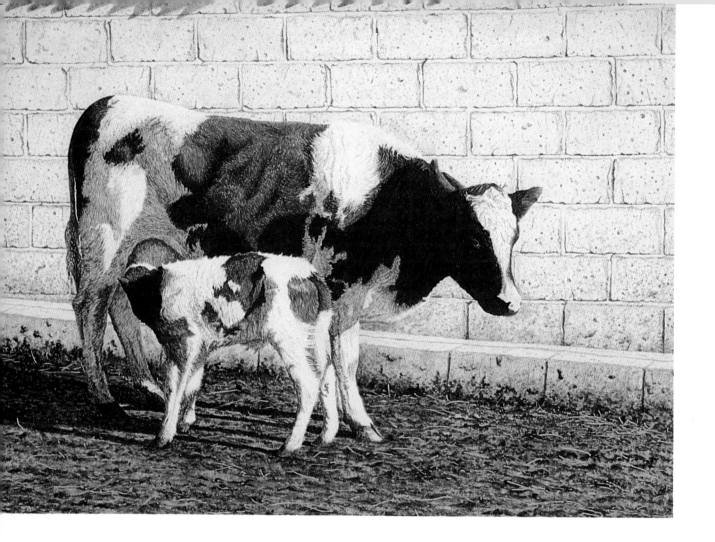

STAGE SIX

Slurry on the yard is painted with mixtures of burnt umber, French ultramarine and yellow ochre. The shadows of the main subjects are strengthened to maintain contrast and finally pieces of straw are painted with a mixture of yellow ochre, Hansa yellow deep and titanium white; this mixture is also flicked onto the yard producing a final texture.

The composition of this painting relies on an interesting interplay of angles. An interaction takes place between the mother and calf because they face in opposite directions. Cast shadows of them move away as the breeze-blocks move slightly towards us. Blocks at the base of the wall follow the contour of the yard which slopes to the right, whilst above, the shadow of corrugated iron slopes to the left; each overall shape helping to balance the other. Another interesting feature is the difference between the harsh vertical and horizontal shapes and lines of man-made objects in comparison with softer curving lines of the main subjects; their softness against hardness creating a textural contrast.

GALLERY

*T*o *fire your imagination a little more, here is a selection of the work*
I have produced over the years. As you will see, detail can be
captured in all sorts of unglamorous subjects – some of my own favourite
paintings are of objects that most people wouldn't look at twice!
Once you start painting detail, you will find inspiration all around you,
so don't hesitate to experiment with subjects,
materials and techniques.

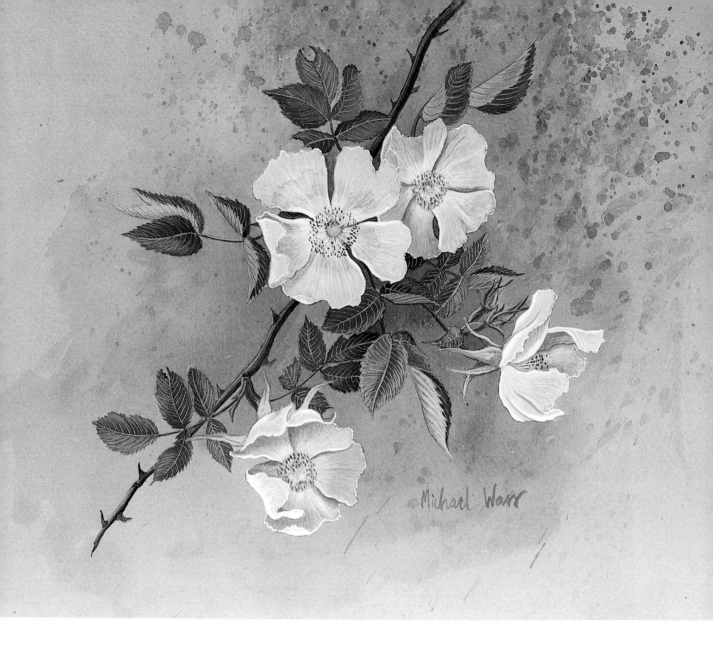

WILD ROSES

Gouache on Tinted Paper

Every year in late spring a profusion of white or pink wild roses can be seen in the hedgerows. After missing these for a number of years, due to painting other subjects, I eventually managed to capture them in this painting. I chose to use gouache, knowing it would help to capture the delicate pale pink of these subjects. A touch of carmine with white did the trick. The veins were painted with a no 000 brush. Precise painting of the flowers and leaves helps them to contrast with the loosely applied weak colour in the background.

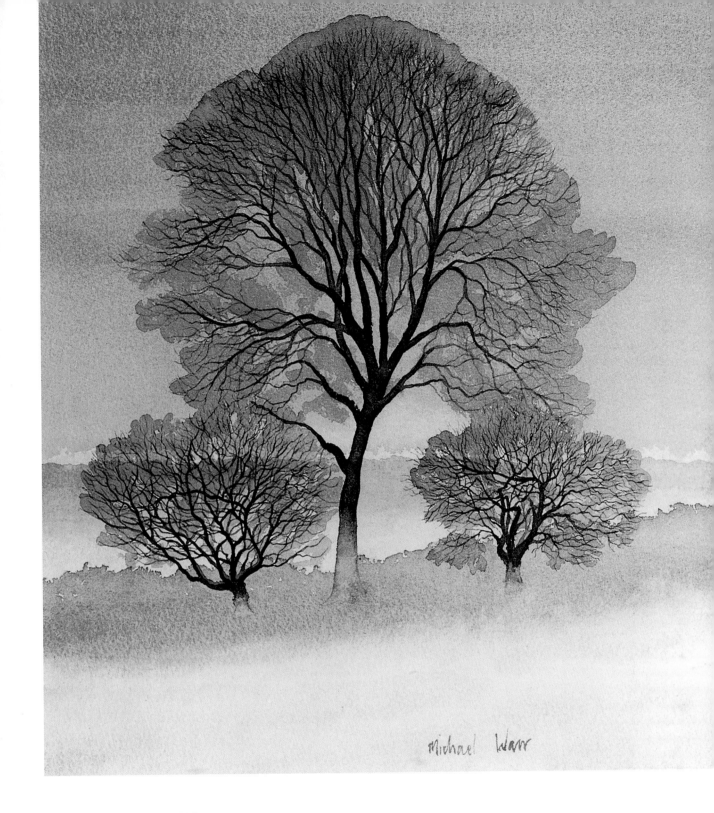

SHEPHERDS' WARNING

Watercolour on Bockingford Paper

Trees are always fascinating; I saw these one morning at sunrise against a red-pink sky, a sign to the shepherd of bad weather to follow. Their stark structures were seen clearly against the contrasting colour behind; the slight foliage forming a watery shroud around the branches.

Early morning mist was rising obscuring the immediate foreground and bases of the trees. This painting shows watercolour in two of its forms: detail in the trunk and branch structures; free-flowing quality in the loosely applied washes of the foliage, fields and sky.

CHEESEMAKER FROM GRUYÈRES

Egg Tempera on Gesso Board

The village of Gruyères in Switzerland is enchanting. It stands high on a rocky crag, its medieval houses and single street cosy within its ramparts, but it was a village cheesemaker who fascinated me with his furrowed brow and wonderful flowing beard. I made sketches and photographs with the intention of doing a tempera painting. The colours used were yellow ochre, titanium white, burnt umber, French ultramarine, lamp black, Hansa yellow deep and alizarin madder. I began by sponging on a few layers of yellow ochre, mixed with titanium white, as a 'high key' or light background was required to suggest a sense of being high in the mountains.

Next came the hat, simply a mixture of lamp black and French ultramarine with a band of Hansa yellow deep. The face and hair followed, the challenge being to capture the fresh, healthy but suntanned elderly character. This was achieved by glazing a mixture of titanium white and alizarin madder over a mixture of titanium white, yellow ochre and burnt umber. The 'character' lines were painted first and the skin colours applied around them. The jacket was tricky, being made from a denim-like material. It was painted with a mixture of French ultramarine and lamp black whilst the embroidered edelweiss and edging on the lapels were a mixture of titanium white with a touch of yellow ochre and Hansa yellow deep. Original white gesso surface had been left for the beard shape. This was tinted with a dilute mixture of yellow ochre and burnt umber and scratched back with a fine steel blade. This process was repeated several times until the portrait was complete.

ARIES

Egg Tempera on Gesso Board

Herdwick rams roam the hills in the Lake District of north-west England. The climate can be very harsh at times and they have developed a very thick woollen coat. A number of things struck me about this subject but I liked the way that the light fell onto the head, creating good contrast between the white face and tawny-coloured body. The hard, shiny horns reflected luminous light here and there, being easier to capture with egg tempera. A dark background was introduced to heighten the contrasts between the light and dark areas within the subject.

Michael Warr

WINTER STORE

Egg Tempera on Gesso Board

In the living-room of my cottage, to the left of a Victorian range, is a log store. Looking at this one day prompted me to make this painting. As you can see, there is slight perspective, lots of texture and surface qualities, all ingredients for an interesting picture. My love of wood is very evident here. There is pine, oak and ash, the logs being pieces of a fallen ash tree given to me by a friend. I remember having to make a decision about whether or not to paint in each score mark made by the chain-saw – how far do we go with detail? Anyway, I decided to and each log became an individual portrait. Eventually they had to be burned and it was like losing old friends.

HIGH SUMMER MORNING

Acrylic on Canvas

Similar to a painting called The Run *this subject was found near my studio. The view is from an old canal bed hence the prolific growth of wild flowers, particularly the wild iris. Cows grazing peacefully under a high summer sky, viewed through a knarled and weather-worn fence, made an ideal painting subject. The fence was built up with ten layers of dilute paint, sometimes wet into wet, allowing slightly heavy colour to float forming the fungi growth. Bright, clear colour was used for the flowers; acrylic paint being ideal for these subjects. Texture in the foreground was produced by speckling and spattering, some of the colour echoing colour seen in the flowers.*

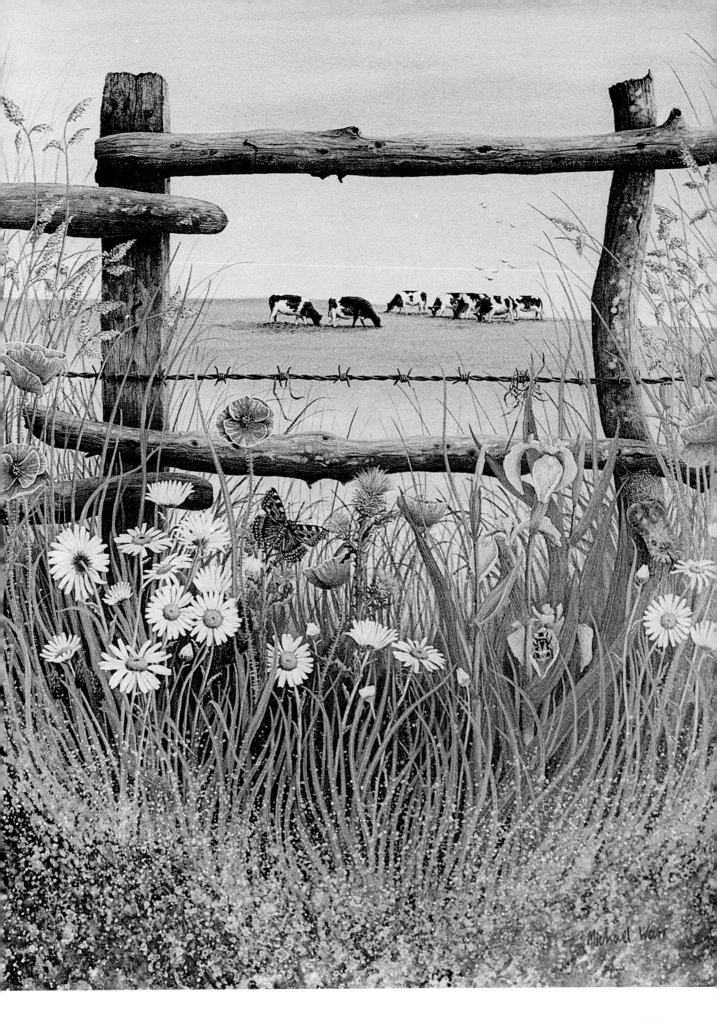

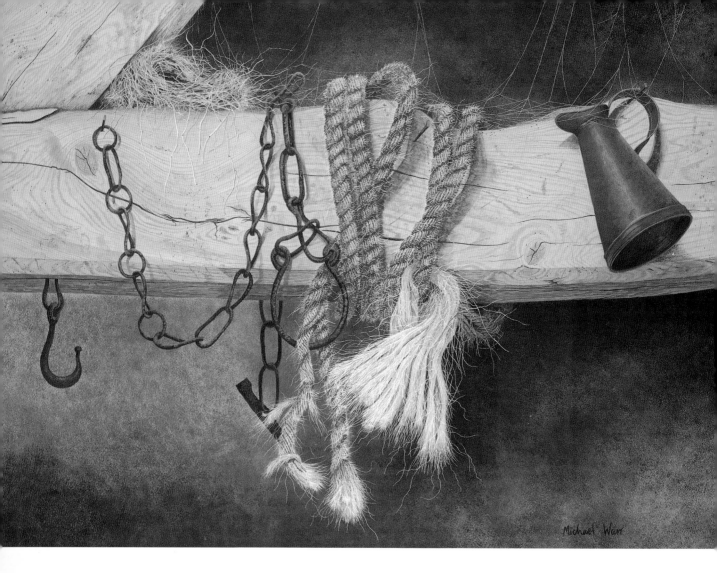

BEAM

Egg Tempera on Gesso Board

The background in this painting has ten layers of thin paint, each applied with a sponge. The texture in each layer changed slightly until the desired 'lighting' effect was achieved. The beam provided scope for producing rhythms and tensions formed by woodgrain. It was important to evoke the feeling of incisions with the grain rather than just painting lines on a wood-like surface. The shape of the grain and textures had to be painted with conviction. A sharp blade was used to scratch in the cobwebs and rope strands. Where I scratched right back to the gesso, I was able to control the colour by use of a weak transparent glaze.

WET OR FINE?

Drybrush Watercolour

It was the texture and colour of the bricks that were the main attraction with this subject, followed by the slight change in perspective of the niche in which the cones were placed. Fir cones are the means by which many country people forecast the weather. When they are open it is usually a sign of dry weather and when they are closed rain is on the way – hence the title.

Returning to the bricks, I found that in my earlier paintings I made bricks too pink but gradually a formula of colour was developed which captured the colour of the hand-made bricks in my area. After lightly drawing the main shapes a wash of dilute raw sienna was laid over the whole area of the painting except for the mortar. This remained white and was tinted a subtle shade later. Washes were then prepared for the bricks consisting of cadmium red and yellow ochre, burnt sienna, raw sienna and burnt umber; also, neutral tint was added for the slightly purple ones. A no 2 sable was used for the

drybrush method of painting and the textures were worked up trying not to build too many layers. The cracks and holes were painted with a mixture of neutral tint and warm sepia with a no 000 sable.

The cones were completed using mixtures of burnt sienna and warm sepia and finally the cobwebs were scratched in with a fine steel blade. I felt that the abstract quality of the painting came through because of the almost 'deadpan' viewpoint. There is little perspective as such and the impact comes from the slight shift in the brickwork above the niche.

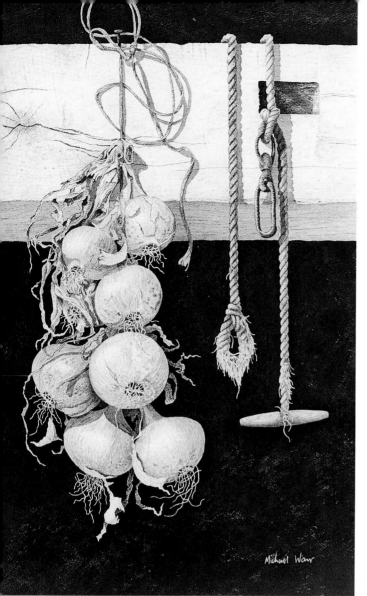

Michael Warr

THE SALT OF THE EARTH

Drybrush Watercolour

The title of this painting relates directly to the life of a retired farming friend. The chosen subjects depict his working life because for over sixty years he was a dairy farmer and also continues to be a vegetable gardener. The rope hanging on the beam is for tethering cows; the onions speak for themselves. There is an interesting colour contrast in the painting which helps to describe the farmer. The warm colour of the onions conveys the warm and generous person but on the other hand the cool colour of the rope suggests that he had to make hard, calculating decisions because of the harsh realities of farming. Again, the dark background was used to add impact to the main subjects.

SACK

Egg Tempera on Gesso Board

The sack in this painting had been slung over a fence by a neighbouring farmer at the end of the potato picking season. I spotted it whilst walking one day and thought that it would make an ideal painting subject. After keeping an eye on it for three years, hoping no one would remove it during this time, I decided that it had reached the right degree of decay and made a drawing. It was possible with tempera to depict the weave of the sack accurately; some strands needed to be light and others dark because of the folds, and staining by the weather. The surrounding fence needed careful attention; the wood grain varied greatly and there were large splits in the post. A steel blade was used to scratch in the web seen in the hole of the post. Wild flowers and a field of wheat behind were painted out of focus, so that they would not detract from the main subject. I included a telegraph pole in the distance to help the composition and also to give a sense of scale and distance to the background of the picture. I would describe this painting as a still life in landscape!

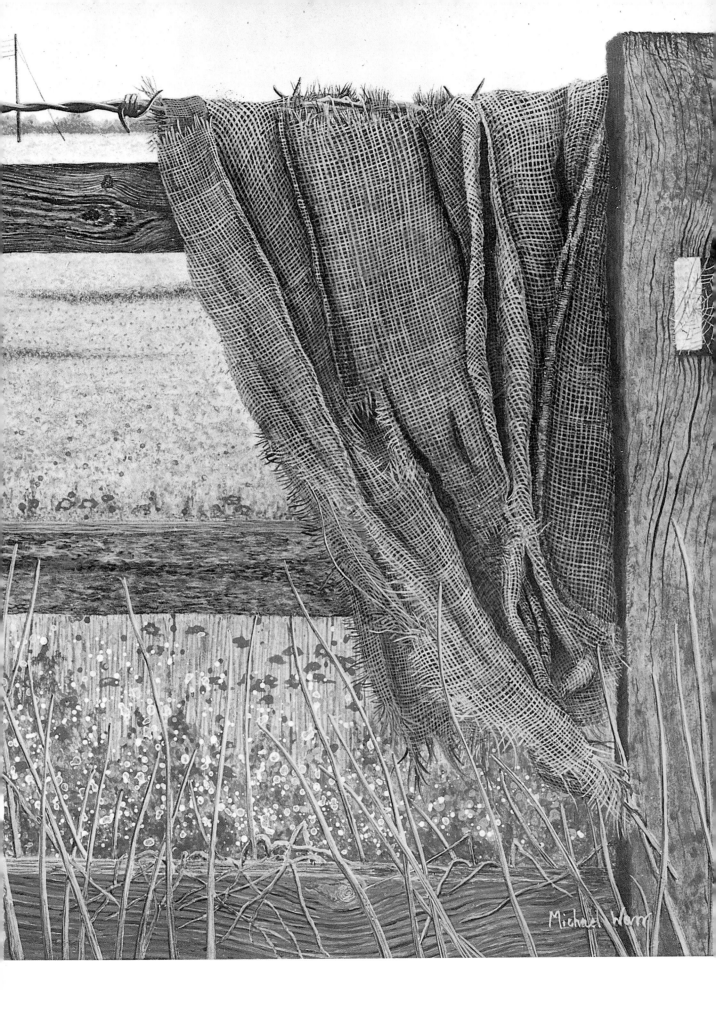

Michael Warr

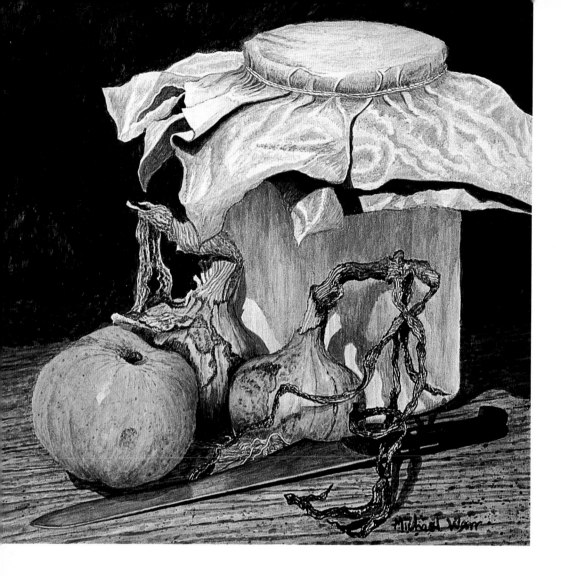

APPLE CHUTNEY

Egg Tempera on Gesso Board

The ingredients of apple chutney inspired this painting but the challenge was to produce the shiny effect of the brown wrapping paper covering the old stone jar. Very light colour was glazed over darker colour to achieve this.

THE RUN

Acrylic on Canvas

After finding this subject in a nearby hedgerow, I made a drawing on location and took it back to the studio. The sheep were added to provide a focal point. Wild animals had formed the run, creating a natural lead-in to the picture. The fence was fascinating because of its peeling bark and interesting woodgrain. It formed a ready-made compositional aid through which the sheep could be viewed. A large briar sweeping in from the right helped to break the severity of the fence. Another interesting aspect I wanted to depict was the brittleness of the vegetation. When walking among dry nettle stems, a delightful crunching sound is heard and knowing that spring approaches and the plants will grow strongly again, treading on them seems to speed up the compost-forming process feeding the new plant life. The immediate foreground depicts this in the form of texture. To achieve a flowing effect the painting was laid flat and I splashed, flicked and spattered the dilute paint onto the surface, enabling the eye to stumble over the foreground and into the picture. Light purple appears amongst the texture echoing the colour used in the brambles.

LUNCHTIME

Drybrush Watercolour on Paper

Contrast is always a good ingredient for painting and this subject is a good example. The picture moves from bright sunlight outside to the dark shadows of an interior. The cast shadows on the row of buckets were interesting as was the dark tone surrounding them. Sunlight was pouring onto the white faces of the calves making them glow. Yellow ochre added to white gouache was used for the shining straw in the foreground. Compositionally the open door acted as a good lead-in to the main subjects.

SAYING GOODBYE

Egg Tempera on Gesso Board

I came across this cart in the old rickyard of a farm one day and felt that I just had to paint it. It provided me yet again with all the ingredients that I love so much! Lichened, bleached split wood and rusting metal parts; the poor old thing seemed to be on its last legs – or wheels – saying goodbye! The brittleness of the subject was very evident and echoed in the brittleness of the dead cow-parsley and nettle stems growing through the cart. To make a contrast with the dry grasses and stems, softer foreground texture was produced with a sponge rather than being speckled and spattered with a brush.

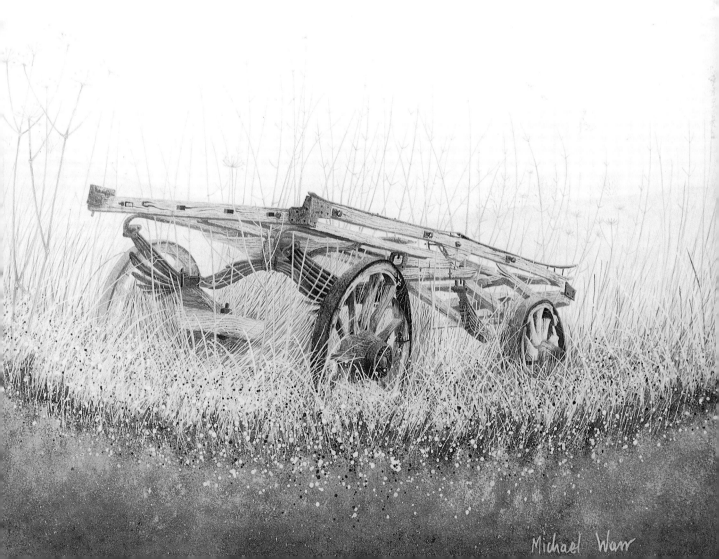

Michael Warr

COMBROOK MURALS

Acrylic on Plaster Wall

Acrylic paint is ideal for murals because of its quick-drying properties, durability and ease of cleaning – a wipe over with a dishcloth will not damage it. These murals were painted within plaster moulding shapes on a wall. Two of them are 2mx1.5m; the third one is 1.5x1.5m. Autumn was the theme, as the colours were suitable for the room. Mural no 1 depicts the house in which they are situated and nos 2 and 3 show the immediate surroundings. Many sketches and drawings were made; these were scaled up and transferred onto the wall prior to painting. A number of dilute layers were applied before the paint was thickened to achieve the final effect.

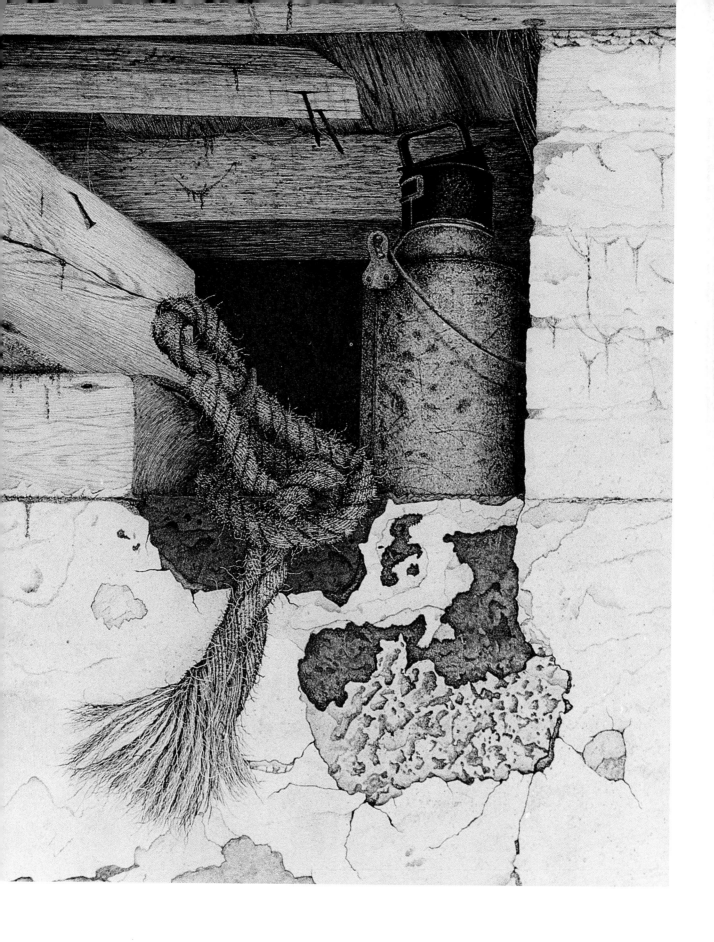

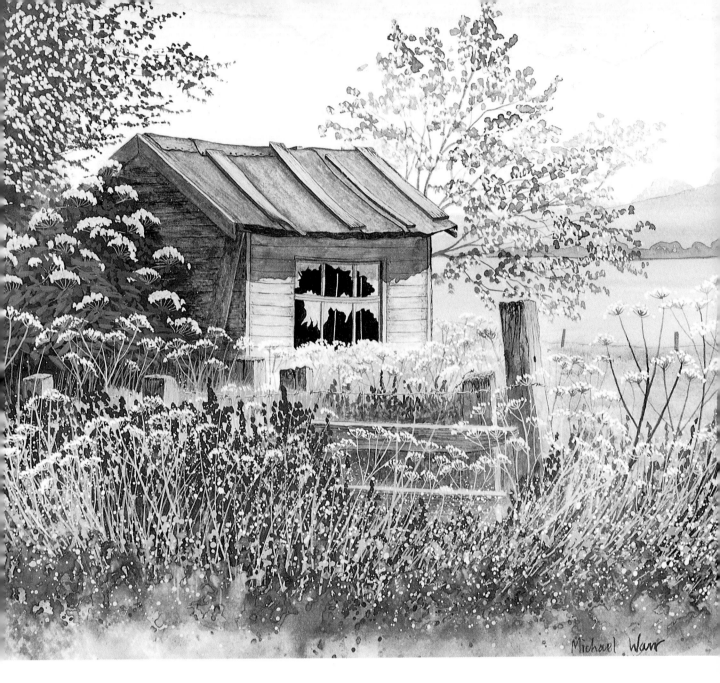

Michael Warr

LEDGE

Egg Tempera on Gesso Board

The intimacy of this little corner in a cow shed attracted me. It had been forgotten; a rusting milk can and worn rope seemed to have been there forever. Tonally, the whole of the subject matter was right; it went from a light white-washed wall back to a very dark space. The textures on the wall were amazing. At some time a salt block had stood on the ledge and this had caused erosion of the whitewash and rendering, creating a crazed effect. Woodgrain moved in all directions; this combined with the other factors made it an irresistible subject to paint.

BEEKEEPER'S SHED

Gouache on Tinted Paper

One aspect of the countryside that fascinates me is the 'frothiness' of late spring. I have tried to convey the feeling in this painting. Gouache on tinted paper was chosen because there was so much white in the subjects; masking would have been impossible. The shed is tatty enough to be interesting and the darkness inside, seen through the shredded polythene, adds extra depth to the painting. Surrounding the shed are hawthorn blossom, elder flowers and masses of cow-parsley in full flower. This is where various shades of white were needed to convey the 'frothy' feeling. Amid this were lichened and worn fence posts and many types of wild flowers. I spattered the flowers with pinks, whites, pale blues and yellows, bringing the foreground to life in a natural random way, rather than painting each shape individually.

POST

Drybrush Watercolour

This post seemed to stand like a lone sentinel defying the ravages of time. The lichen, splits and wavy cracks were enchanting, as was the rusting chain with its deposits of white lime. The exposed wood had become bleached to a subtle shade of light grey over the years. I used a dilute mixture of Paynes grey and lamp black to depict this. Cadmium yellow pale and Paynes grey were used for the lichen; burnt sienna and warm sepia were the ingredients for the rusty chain, leaving a slightly tinted area of paper for the white deposit. To add impact to the sentinel-like feeling of the post, the background was painted with neutral tint and warm sepia. The slight angle of the post in relation to the rectangle and the proportion of surrounding space were important from the compositional point of view.

WARWICKSHIRE LIGHT

Egg Tempera on Gesso Board

'This painting was inspired by Holman Hunt's Light of the World, *perhaps one of the most famous examples of English religious art. Michael Warr has spent over six hundred hours of painstaking work on this, his tribute to Holman Hunt. He has tried to capture that same feeling of peace and hope which is there for us all if we open the door of our soul and let the light spill in. The calf is just caught in the shaft of light coming through the doorway and the sacking almost becomes a stained glass window with the light beyond. This is the feeling that came to Michael Warr as he stood in that stone cow shed with its ill-fitting door and from these thoughts came a work of art.'*

DAVID GLAISYER, ASTLEY HOUSE FINE ART

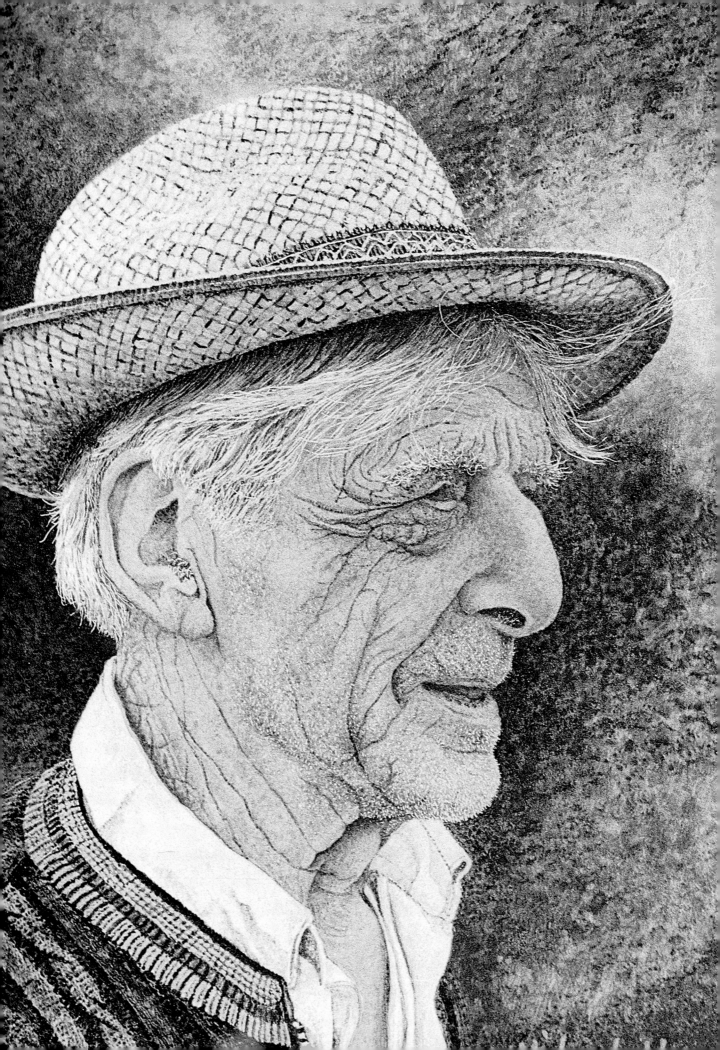

THE BEEKEEPER

Egg Tempera on Gesso Board

I have known this man for several years. He has kept bees near my home for seventy years (using the same hives would you believe)! He always wears the straw hat, it seems to be part of him. Painting him seemed a natural thing to do; his face, full of character, offered tremendous scope. A steel blade was used to depict his silver-grey fine hair, the eyebrows and stubble. The background was produced by applying paint with a sponge.

MILL WHEEL, VALAIS

Egg Tempera on Gesso Board

Needless to say I raved when I discovered this old mill wheel still being used in the Valais Canton of Switzerland. Apart from the textures on the façade of the building the set-up to transport the water to the wheel seemed like an original Heath-Robinson job! The whole subject was crying out to be painted. Egg tempera was chosen because I felt that precision was needed. Although the paraphernalia to transport the water looked precarious, it relied on precision to direct the flow onto the appropriate part of the wheel. The water offered a challenge in terms of painting but the luminosity of egg tempera helped a great deal with the flowing water, splashes and runs. Colours used in the painting were burnt umber, French ultramarine, titanium white, yellow ochre, alizarin madder and Hansa yellow deep. I particularly liked the purple-grey colour of part of the wooden structure, this being conveyed with a mixture of burnt umber and French ultramarine. A mixture of yellow ochre and alizarin madder with a little burnt umber was used for the delicious orange in the woodgrain. A white gesso area was left for the flowing water and tinted with dilute colour. Crystal clear runs and splashes of water were scratched in with a fine blade. The subject was surrounded by a profusion of wild flowers and lush green grasses, the latter being produced from mixtures of French ultramarine, Hansa yellow deep, titanium white and burnt umber.

POSTSCRIPT

Although painting detail requires a certain amount of rigid discipline, particularly at the drawing stage, there is scope for experimenting with the techniques of various media. The textural qualities of subjects are the areas to be exploited. When the basic shape of a subject has been produced correctly, the surface of that subject lends itself to much textural experimenting. Look at objects and their surfaces to decide which media you might like to use, going on to discover, within the bounds of the medium, how you will portray the character or quality of the subject. Try to look and interpret the 'looking' in terms of the paints that you have at your disposal – every colour and texture that we see in nature cannot be reproduced exactly. Remember that we are painting and can only work within the limitations of a medium on a flat surface. The freedom to change composition, colour, shape and texture should always be there!

INDEX

acrylic equipment 23
acrylic paint 23, 36, 37, 38, 39, 84, 88, 108, 114, 118
acrylising medium 23, 76
Alpine Daisies 80
Apple Chutney 114
Aries 106
At the Ready 66

Beam 110
Beekeeper's Shed 121
Beetle Sculpture 84
Bless This House 60
brushes 22, 23, 24, 25

candle wax 28
canvas 24, 108, 114
canvas board 23, 84
Cheesemaker From Gruyères 106
Clinker Built 56
coloured pencil 14
Combrook Murals 118
Constable, John 56

distilled water 24, 40
drawing board 8, 9
drawing equipment and techniques 8-19
drawing table 9
drybrush technique 32, 33, 39, 48, 63,
 66-71, 78, 79, 111,112, 116, 122
Drying Beauty 70

easel 22, 23
edge 50, 52
egg tempera equipment 24, 40
egg tempera paint 24, 40, 92, 98, 106, 108, 110, 112,
 114, 117, 121, 122, 125; ready made 24
egg yolk 24, 40
eye dropper 25, 40

felt tip pen 16
fibre tip pen 16; water soluble 16, 17
file 9, 11
folding stool 8
flow improver 24

Gertch 88
gesso board 24, 25, 43, 88, 92, 98, 106, 108, 110, 112,
 114, 117, 121, 122, 125
gesso powder 25
Glaisyer, David 122
glaze 37, 86, 110
gouache equipment 22, 23
gouache paint 22, 31, 34, 35, 55, 76, 80, 116, 121
granulation 26, 44, 56

Henry 92
high density fibreboard 24, 25, 88
High Summer Morning 108

ink 17, 18, 19, 32, 35

Kerry 76
kitchen roll 30
knifing out 31, 32

Last Hinges 46
Last of the Ayreshires 98
Ledge 121
lines 29, 39, 43
Lunchtime 116

mapping pen 17, 18, 19
marine plywood 25
masking fluid 28, 29, 47, 48, 50, 53, 56, 58, 61, 63
materials and equipment 20-25
mixed media 19
Mountain Hut 50